kawaii!
japan's
culture of cute

kawaii!

japan's culture of cute

manami okazaki & geoff johnson

PRESTEL

Munich · London · New York

contents

introduction 6

the roots of kawaii 10
Yayoi-Yumeji Museum 12
Eico Hanamura 18
Kyoto International Manga Museum 24
Macoto Takahashi 28
Yumiko Igarashi 32

cute design overload 36
Hello Kitty 38
San-X 48
PetWORKs 52
Gloomy Bear 58
Kigurumi 62
Swimmer 66
Bukkoro 70
Nameneko 74
tokidoki 78
Street Cute 82
MonsterGirls 84
Paro the Seal 86
Itasha 88

adorable eats 92
Maid Cafés 94
Bento Boxes 98
Kewpie Mayonnaise 102
Micarina 106
Kazarimakisushi 108
Kintaro Ame Honten 110

how to dress kawaii 112
FRUiTS 114
Harajuku Map 118
Harajuku Fashion Walk 122
POP n CUTE 130
Cosplay Street Snaps 134
Takuya Angel 136
6%DOKIDOKI 140
Conomi 144
Nails 148
Gothic and Lolita Models 152
Hangry & Angry 156
Hanabi 160
Comiket 166

cute crafts 170
Otome Kokeshi RIBBON 172
Design Festa 176
Kokeshi in Naruko Onsen 180
Kokeshka 184
Useless 188
Michi66 190
Larger than Life 192

kawaii visual art 194
John Hathway 196
Chikuwaemil 200
Yosuke Ueno 204
Yoskay Yamamoto 208
Shojono Tomo 210
Junko Mizuno 214
Osamu Watanabe 218

image credits and acknowledgements 222

6

Arcade games are often where cute characters gain their popularity.

introduction

If there is a word used by Japanese girls more frequently than any other – several times a day, at least – it is kawaii. Roughly translating as 'cute', kawaii describes the adorable physical features that kids and baby animals have, and anything that breeds feelings of love and the motherly instinct to care and protect. In Japan, this has become an all-encompassing ideal. The word 'kawaii' can be used to describe the atmosphere or perceived qualities of something as well as its appearance.

Nowadays, 'kawaii' is a complimentary adjective applied in mind-bogglingly varied ways: it is synonymous with beautiful, lovable, suitable, addictive, cool, funny, ugly but endearing, quirky and gross. You are just as likely to hear a table, car, building, doughnut or plane being referred to as kawaii as a newborn puppy – and in Japan, quite often, the most banal things *are* cute. In the past, kawaii things were always immature and small, whereas now you will hear the word used to describe the elderly, and even the royal family. This is reflective of changes in the hierarchical nature of Japanese society – nowadays, so long as it softens the heart, it will be called kawaii.

The word itself has gone through several iterations. It is thought to have derived from *kahohayushi*, which is shortened to *kahayushi*. In common parlance it was used as *kawayui*, which was then changed to kawaii. In the Tohoku and Hokkaido dialects, it is still more common to use the word *menkoi*.

The rise of cute idols in the 1980s meant that girls not only wanted adorable things, but to *be* kawaii as well. Popular girls' manga of the time portrayed a female ideal that was saccharine-sweet and endearing, but with a strong fighting spirit and a drive never to give up. Fashion labels sprung up in Harajuku, a neighbourhood that came to embrace kawaii as an aesthetic quality to be constructed through fashion

and make-up. Because of this, many girls in Japan would much rather be called cute than glamorous, sexy or pretty.

Product design, aided by the rise of letter-writing, manga, anime and characters like Hello Kitty, has also helped to create a huge kawaii culture. Designers have realized that the Japanese love of kawaii trumps all – where else in the world can you find cute public buses, frying pans, golf balls, fans, motorcycle helmets, cars, planes and AC adaptors with dopey-looking bears emblazoned on them? Kawaii is also commonly used to make communication smoother between girls. All girls can empathize with what kawaii is, and saying 'You are kawaii' simply suggests 'I've noticed you', or 'I am interested in you.'

What makes something kawaii? Aside from pastel colours, a compositional roundness, the size of the eyes, a large head and the short distance from nose to forehead, quite often it is things or people that are not trying to be cute. Girls who try too hard to be cute are referred to as *burriko*, which has connotations of fakeness. Conversely, since the 1990s, kawaii has commonly been teamed with words that connote precisely the opposite of cute, creating a bevy of increasingly ubiquitous spin-offs such as *guro-kawaii* (grotesque cute), *kimo-kawaii* (creepy cute), *busu-kawaii* (ugly cute), *ero-kawaii* (sexy cute) and *shibu-kawaii* (subdued cute), which deviate from standard notions of what cute entails.

This book looks at kawaii in its multiple guises. Kawaii does, of course, have a lot to do with aesthetics, but it also reflects changes in social structures and the role of women, the rise and fall of the economy and a sense of national identity. This book contains interviews with many of the cultural luminaries who have helped create the Japanese love of cuteness, bringing you on a holistic tour of the world of kawaii, from the sublime to the ridiculous. Enjoy!

Manami Okazaki

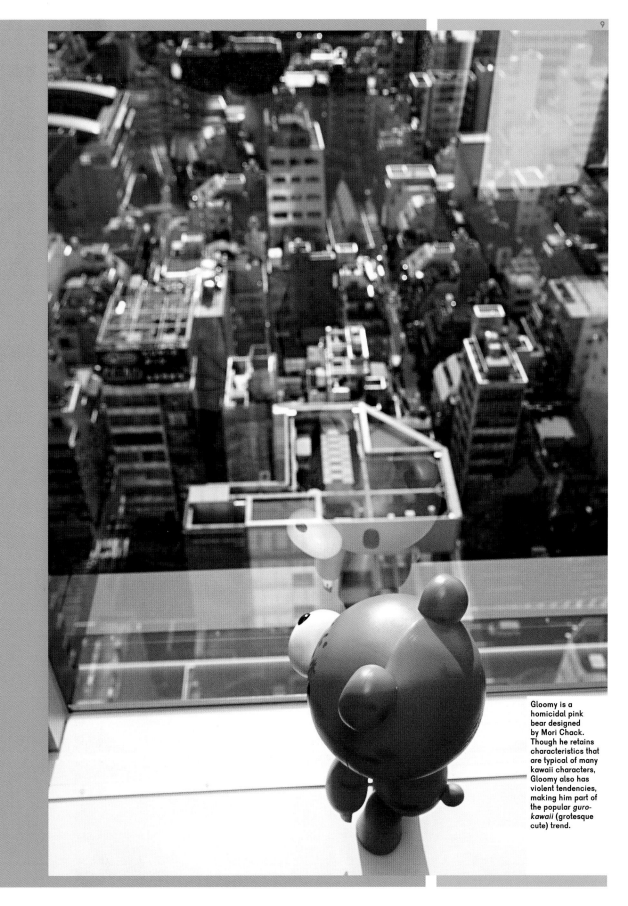

Gloomy is a homicidal pink bear designed by Mori Chack. Though he retains characteristics that are typical of many kawaii characters, Gloomy also has violent tendencies, making him part of the popular *guro-kawaii* (grotesque cute) trend.

the roots

of

kawaii

The Japanese notion of kawaii has been cultivated over decades, and was developed through the passion and talent of some of Japan's most important artists and designers. However, the factors that contributed most to the development of kawaii were girls' illustrations, *shojo* manga and the merchandising of fancy goods.

Fashionable illustrations have been popular in Japan since the Edo era (1603–1868), when *bijinga* ('beautiful person picture') woodblock prints depicted lovely women wearing gorgeous kimonos. This culture of *bijinga* continued through the Meiji and Taisho eras (1868–1926), though they were made using increasingly sophisticated printmaking technology and featured progressively more Westernized dresses.

Yumeji Takehisa is considered the first kawaii *shojo* (girl) illustrator, and his distinct style, which fuses Japanese traditional painting with European influences, is phenomenally popular with women in Japan today. He is also credited as being the first kawaii goods proprietor, with his shop Minatoya Ezoshiten opening in 1914; it sold various items for well-to-do girls such as letter sets and small bags.

Under Japanese militarism and World War II, cute things were not seen as favourable. It was really after the war that kawaii boomed, aided by the proliferation of *akahon* (cheap manga) and *kashihon* (manga to rent) culture. Kiichi Tsutaya's paper dress-up dolls flourished in popularity, as did girls' illustrations, which were often created by artists who were fascinated with the foreign culture they witnessed during the American occupation.

In 1946, Junichi Nakahara, another seminal illustrator, created *Soleil* magazine, which is still highly influential on fashion designers. However, *Soleil* was hardly the first magazine of its kind – *Shojo Kai*, which Nakahara contributed to, started in 1902. Illustrators also made their own children's picture books as well as working on literary publications and novels. By the mid-1950s, the *shojo* manga industry had developed to such an extent that magazines which exclusively published it, like *RIBON* and *Margaret*, had been established.

Gradually, women *shojo* illustrators and manga artists came to the fore, particularly in the 1970s. Titles such as *Rose of Versailles* by Riyoko Ikeda, based on the French Revolution and Rococo high society, and *Candy Candy* by Yumiko Igarashi became, and still are, staples for most Japanese girls. As the *shojo* manga and girls' illustration industry became more female-dominated, the importance of kawaii fashion within manga grew. Illustrators like Macoto Takahashi and Eico Hanamura portrayed the most exquisite fashion in their work. The clothing they depicted in their manga wouldn't look out of place on the streets of Harajuku today.

As Japan entered the economic bubble of the mid-1980s, companies such as Sanrio went all-out in creating kawaii products that featured characters like Hello Kitty. This trend hasn't waned since the bubble burst, and there is no end in sight for the proliferation of cute goods in Japan.

This chapter features some of the most influential figures in the creation of kawaii culture as we know it today. Their timeless work bridges generations, showing that the love of all things adorable transcends age.

Top: Rune Naito was one of the first artists to popularize the term 'kawaii'. His girls usually sport huge eyes and proportions similar to babies.

Bottom left: Manga artist Eico Hanamura is famous for her stylish illustrations of girls and is still considered influential in the fashion industry because of her funky designs.

Bottom right: Yumeji Takehisa is the pioneer of what are known as 'fancy goods' – which roughly correspond to kawaii character products today.

Yayoi-Yumeji Museum

In Japan, there are kawaii items everywhere you look. Any product you can think of has a kawaii equivalent waiting coquettishly in its box at the shops, and cute-obsessed consumers buy them by the bucketload. Where does this culture come from? The Yayoi-Yumeji Museum, which is made up of two spaces, the Yayoi Museum and the Takehisa Yumeji Museum, is dedicated to girls' magazine illustrators. It hosts many exhibitions each year with the goal of promoting knowledge about kawaii's rich history.

Keiko Nakamura, *Curator, Yayoi-Yumeji Museum*

Playing cards
by manga artist
Katsuji Matsumoto.

Said to be the godfather of cute culture, Yumeji Takehisa blends Japanese and Western artistic sensibilities using motifs that had never previously appeared in Japanese design, such as umbrellas and mushrooms, like these prints from 1913–15.

What does 'kawaii' mean, exactly?

It is the appeal of adolescence, when one is not yet an adult. Kawaii things are usually soft, bright, round and small. They aren't aggressive or belligerent: they give you peace of mind and a sense of security. Originally, the word was used to describe people who were beneath you. It was acceptable to use it when referring to objects, but you wouldn't use it for your superiors or fellow schoolmates. But since the mid-1980s, girls have generally preferred to be called kawaii rather than simply pretty.

What are the historical roots of kawaii culture?

I consider 1914 the birth year of kawaii in Japan. That's when the illustrator Yumeji Takehisa opened a shop in Nihonbashi which sold numerous goods aimed at schoolgirls – what we now refer to as 'fancy goods'. Items that were desirable at the time included woodblock prints, embroidery, cards, illustrated books, umbrellas, dolls and kimono collars. Up until then, there hadn't really been any shops that were aimed at a

particular clientele based on age or gender, but the customers of this shop were mostly young women. At the time, of course, they weren't using the term 'fancy goods', but *komamono*.

Takehisa was influenced by foreign cultures, and his goods show an aesthetic meeting of East and West. He designed coloured paper with poisonous mushrooms, for example. At the time, in Japan, this wasn't done, but in the West in the early 1900s poisonous mushrooms appeared on cards and in illustrated books.

He also designed *chiyogami* paper with motifs like umbrellas and matchsticks. At the time, *chiyogami* was usually printed with traditional *yuzen* patterns, so his thinking was very innovative and a lot of people came to copy him. Takehisa placed importance on the cuteness of his designs and referred to them as kawaii. However, this is a rare example of the word being used at the time, as it wasn't a commonly used word, as it is now.

How have Japanese notions of beauty changed over time?

If you compare the work of Takehisa and the painter Ryushi Kawabata, their notions of what constitutes beauty are very different. Takehisa's illustrations look cute in comparison to Kawabata's work because there is a roundness to them – especially the eyes. Kawabata paints eyes in the shape that is common in Japanese classical painting; having small eyes and a slender physique was considered to be the ideal. Round eyes were traditionally seen as vulgar, although the ideal changed with foreign contact. Artists began to follow Takehisa's style. One of these was Junichi Nakahara, who drew eyes very large. He introduced the notion that girls on paper didn't have to replicate reality.

The Great Kanto earthquake happened in 1923, and Tokyo was obliterated. From that time, Takehisa's popularity declined and various designers became prominent, although at the time they weren't called designers – they were called *zuanka* and were all influenced by Takehisa.

Kaichi Kobayashi from Kyoto, who draws quite mature-looking images, was one of these designers. He made envelopes and letter paper for schoolgirls.

What were these letter sets used for?

They were becoming increasingly important items for schoolgirls. Before the Taisho era [1912–26], girls went to elementary school and then got married or went to work, but during this period more girls continued their education. They were generally from upper-middle-class families and had a lot of spare time, which they spent writing letters. Meeting up with boys was strictly forbidden at girls' schools, so they would play games where they would write love letters to their classmates instead, or to girls that they looked up to or thought were cute – almost every day! At the time, of course, there was no Internet, so letter sets became very important and were the huge hit item of the era.

People that followed directly from Takehisa's trend were artists like Nakahara, who opened a goods shop called Himawariya [sunflower],

and Katsuji Matsumoto, who was active from the beginning of the Showa era [1926–89]. Matsumoto is thought to be the originator of *shojo* manga in Japan, and *Kurukuru Kurumi-chan* the first example of it. The protagonist, Kurumi-chan, is considered the first character icon: there were Kurumi-chan *kisekai* dolls [dress-up paper dolls] and stickers, as well as postcards that were meant to encourage troops during the war. The story itself is really quite simple: Kurumi is a five-year-old who is always merry, and hence lovable. It is uncomplicated, and audiences today might wonder what is so good about it.

In the 1950s and 1960s a lot of fancy goods came on the market as Japan's economy improved. There were improvements in raw materials and technological advances. Directly after the war there was a baby boom and, as these babies grew up to be teenagers, the market for goods aimed at this age group increased.

Setsuko Tamura used food motifs on handkerchiefs like these in her early work, even as soon as 10 years after the war. These signified the rapid economic recovery and gradual affluence which later led to the economic bubble.

Rune Naito's name comes up a lot in reference to kawaii culture. How influential is his work?

He popularized the word 'kawaii'. When you look at his drawings, the ratio of total body length to the size of the head suggests the proportions of a very little girl. The facial features are those of a newborn baby, with a large, round head. The distance from the hairline to the eyebrows is really long, giving the face a large forehead, and the nose and mouth are really small. His work was initially seen as a bit weird, but became very popular.

Prior to this era, Japanese women had to mature and become adults quickly because poverty was rampant, and people were encouraged to have a lot of children to provide a labour force and recruits for the Army. In fact, it was common for families to have between seven and ten kids. When the men went to war, the women had to work. In the mid-1950s the guys went back to work and the girls didn't have to grow up as fast.

Kiichi Tsutaya was known for his colouring books and paper dress-up dolls, like these from 1945–55.

Handkerchiefs by
Rune Naito.

When did seminal *shojo* manga artists come into the picture?
Artists like Masako Watanabe and Macoto Takahashi, who drew gorgeous and opulent images, became the most influential people in terms of manufacturing goods. Ado Mizumori was also hugely influential. Something she did that was new was to put a touch of eroticism into the cuteness. For example, her characters had large, round bottoms, and appeared in kissing scenes. You could say this was the beginning of *ero-kawaii* [erotic cute]. From there, the notion of kawaii branched off in different directions.

How did Sanrio goods become explosively popular?
From the mid-1960s to the 1970s, manga like *Candy Candy* were very important, as were dolls such as Licca-chan. In the 1980s, when Tokyo Disneyland opened, they sold many goods and it became common for everyone to have at least one Disney item in their house. The birth of Hello Kitty in 1974 was a landmark event too. Though Sanrio had been around previously, selling strawberry-themed goods or Ado Mizumori products, nothing came close to the Hello Kitty boom.

Ado Mizumori was one of the first artists to add a sexy touch to her kawaii illustrations, which is commonly called *ero-kawaii* today.

Why were so many goods produced at this time?

This was connected to the oil and dollar crisis [due to the 1973 Arab oil embargo]. Up until then, the general goods industry had been aimed at exports to America, but because of the economic climate of the time they had to focus on the domestic market instead. The success of Hello Kitty led to the realization that if you made something cute, it would sell. As a result, various companies jumped on the goods-manufacturing bandwagon.

When the economic bubble burst, Japanese people became a bit poorer and wanted to buy inexpensive things, so 100-yen shops started up. A lot of fancy goods came to be manufactured just for this market and, because of this, they came to be seen as kitsch and cheap. Before this generation, it was upper-class girls who had bought kawaii. But now everyone could have inexpensive fancy goods. At one point the industry wanted to call them 'variety goods' instead! Unsurprisingly, that wasn't a successful idea. Since then, there has been a stream of hit characters, like Tarepanda from San-X, and similar companies have made more and more kawaii items.

The popularity of kawaii objects can be traced back to stationery and letter sets. This memo pad decorated with Masako Watanabe illustrations is an example of early kawaii goods.

Masako Watanabe's classic kawaii girls in 'Venus', 1955—65.

Eico

Hanamura

Eico Hanamura is an artist who has been drawing *shojo* manga, such as the celebrated *Some Girl in the Fog*, since 1959. She is known for her colourful illustrations of doe-eyed girls with long eyelashes in gorgeous psychedelic apparel. Hanamura is one of the most influential, pioneering manga artists in the world. Her fashionable drawings look so fresh today that it is hard to believe they are decades old.

Where are you from?
Kawagoe in Saitama Prefecture: maybe that is the reason why I like old things. It is a historic Edo-era castle town, and still has that atmosphere. The house I grew up in was an old warehouse-style abode from the Genroku era [1688–1704], and had the kind of things you see in TV period dramas, like old paper lamps, ashtrays and braziers.

When did you become an artist and how did you get your start in the industry?
I went to Osaka. The apartment building where I was staying had a library on the first floor, and the owner was a manga illustrator. I really loved to draw and I was going to Joshibi University of Art and Design and studying theatre at Keio University. There are big similarities between directing and drawing manga: like manga artists, film directors build a story with camera work using close-ups, long shots and landscapes, and decide where props should come into play.

When I showed the owner of the library my work, he told me to start drawing manga. I didn't know anything about manga, so I just drew 30 or so illustrations with a narrative and took them to a publisher – who bought them straight away. I had no desire to be a manga artist, but I was

Manga artist Eico Hanamura at her studio in Ajiro.

Paper doll, 1973.

Hanamura has created cover illustrations for many children's notebooks; these are from the 1970s.

so happy! After that I became a regular. I was doing monthlies, and then eventually a longer serial that ran for a year, which was quite popular. At the time, I had a husband, and we went to Tokyo together. The publishing house Kodansha had a magazine called *Nakayoshi* and they sent me a letter asking if I wanted to work for them.

The publisher Shogakukan ran a monthly magazine for young girls called *Jogakusei no tomo*, which had a lot of spreads with cute illustrations of girls, and I really wanted to draw like that. I had no desire to be a manga writer, but I was told by *Nakayoshi* that I was going against the tide of the times and that the future would be the era of manga. They told me that if I drew manga, I would eventually be able to do those spreads too, but I needed to do the manga first. Basically, I was talked into it by the editor!

After that, *Shojo Friend* gave me commissions for regular *shojo* manga jobs, and then Shueisha Publishing came along with an offer. Even then, I still wasn't thinking I would be a manga artist, but I really got caught up in it.

When did you develop your style?
I didn't have a style per se, but when I was a child I liked the illustrator Junichi Nakahara,

so I copied his work. I liked the manga-like look and the large eyes. Unlike now, most homes did not have a TV set, only books and magazines, and after the war there weren't many beautiful books like the ones you see now. Nakahara is one era before me. A friend showed me his work, and I was really astounded that such a beautiful thing even existed.

Did starting out during Japan's post-war era affect your work?
Yes, and not only me. If you look at the heroines of *shojo* manga of the time, they are always poor. They are good, lovely girls but poor, and the girls that tease them are usually rich.

When foreigners look at Japanese *shojo* manga they think the eyes are huge. Where does this look come from?
I think it's a Japanese insecurity. In the beginning, we would draw foreigners and call the work 'no-nationality manga', as it wasn't clear which country they were from, although they had huge eyes, large noses and fluffy hair. It was a kind of ideal. We had seen foreign films in which they had lace curtains and things like that, and we were fascinated by overseas things! But when foreigners look at my work they say it looks totally Japanese. I have been told that

the patterning on the clothing is similar to woodblock prints but I am not conscious of it.

What is the most difficult aspect of drawing manga?

The face. There are times when I can do it instantly and other times when it doesn't matter how long I take – I just can't do it. In the past, when I was working at weekly magazines and monthlies, there were many nights when I couldn't sleep. When I woke up, I had drawn the weirdest stuff that I had no recollection of even drawing, like a really cute girl with a moustache; I really was in a daze!

The girls in your manga have great fashion sense. Did you study fashion?

When I was drawing these girls there was no one wearing colourful things like that; they were just clothes that I imagined. I have been told that fashion designers are inspired by my illustrations, but at the time I wasn't looking at fashion magazines, although I loved to make clothes.

Your style has changed dramatically. When did you start favouring the more mature ladies that you draw now?

During the 1970s and 1980s, ladies' comics [manga for mature women] were really popular. Even publishing houses that don't make manga wanted to jump on the bandwagon. They were all around 40 pages, lots of office romances and nurses.

I didn't really like them – I preferred to depict women that made things, like kimono dyers, or designers, artists or actresses. There was also a boom of erotic ladies' comics, which subsided really quickly too.

What is popular now?

Otaku [geek] style, really niche subjects like Go and *shoji* [Japanese board games], and food themes. I wanted to do a food-themed manga once, but *Oishinbo* [a cooking-themed manga] came out and I felt that niche was taken. But then there was suddenly an avalanche of food titles – I should have just done it!

Cover illustration for *Some Girl in the Fog*, 1966.

Kyoto

The museum also hosts cosplay events.

International

Manga

Kyoto International Manga Museum is a veritable treasure trove of manga. Not only does it house 300,000 titles, the largest collection in the world, but it boasts numerous displays highlighting the history of manga culture and features rotating exhibitions. Established in conjunction with the Kyoto City and Kyoto Seika University, the museum restores, preserves and aids in research on manga.

Jessica Bauwens-Sugimoto, *Postdoc Research Associate, International Manga Research Center, Kyoto Seika University*
Noriko Inomata, *Researcher, Kyoto International Manga Museum*

Museum

Has there always been a divide between manga for girls (*shojo* manga) and boys (*shonen* manga)?

JBS: There has been a divide in magazines for boys and girls since the first youth magazines appeared in Japan. The first magazine for girls appeared in 1903. While there wasn't a lot of manga content in them at first, eventually it increased exponentially, and it was magazine culture that was at the origin of the flourishing post-war manga culture.

After the war, how did perceptions change on how to be the 'ideal woman' as expressed in *shojo* manga?

JBS: The ideal woman went from being innocent, sweet, obedient and childlike [as often drawn by male artists until the mid-1960s] to being fashionable, adventurous, open-minded and a lot more diverse [as often drawn by female artists since the 1970s].

What have been some overriding trends in *shojo* manga themes and who created these trends?

NI: *Shojo* manga used to be all about a girl's happiness. This changed over time. After the war, many readers could recognize themselves in stories in which a displaced girl was reunited with her family, for example. Then Japan's economy developed rapidly and readers got older too: the main themes in the 1960s were love stories set in high school. After that, the Magnificent 49ers [a group of manga artists who were born around 1949] started introducing genres that so far had not fitted into the framework of *shojo* manga, such as sci-fi and boys' love [homoerotic manga, by artists like Keiko Takemiya and Moto Hagio], creating greater diversity in themes. Even today, the image of *shojo* manga as synonymous with romance is very strong.

As far as expressions are concerned, drawing stars in the characters' eyes was an illustrative style that Macoto Takahashi first introduced in the 1950s. Takahashi was known for drawing characters out of the frame – as large as three vertical panels. In the 1980s, artists like Taku Tsumugi layered their panels to express a character's psychological state.

Trends were created through the strong relationships between Japanese editors and artists – that is to say, the editors took readers' reactions into account, often telling the artists what to change. So, it is the interplay between author, editor and readers that creates trends.

When did clothing and fashion become an important aspect of *shojo* manga?

NI: After the war, stylish illustrations which depicted full-body shots became an important element of *shojo* magazines, and this trend continued in *shojo* manga. That is because at that time there were no fashion magazines aimed at teens. *Shojo* magazines shifted their content from text to more visual material like manga, and therefore took on the role of being fashion magazines. Girls focused on the fashion the manga heroines wore.

The lawn of the Kyoto International Manga Museum.

How have the consumers of *shojo* manga changed?

NI: The audience for manga has become very diverse. Until about the 1950s, most *shojo* manga readers were elementary school students. Since the 1970s, more manga magazines aimed at older readers have been published, and the average age of the readers has gone up. Female university students started reading manga. Today, there are specialized manga magazines for working women, women with children, housewives and women who have a difficult relationship with their husbands and mothers-in-law!

How much is the aesthetic of the female protagonists in *shojo* manga influenced by the West?

NI: In post-war Japan, admiration for Western Europe was depicted in manga more and more. Even if the setting was Japanese, the faces of the main characters would be Westernized, with large eyes. Their lifestyles – the houses they lived in, their beds, tea sets and clothes – had a Western aesthetic too: a lot of frills and lace were drawn on everything. Girls admired these settings.

Some critics say that the large eyes of manga characters meant that girls admired Western looks, but for the artists it was also a question of technique. Those who didn't draw complete backgrounds and bodies would often use close-ups of facial expressions. *Shojo* and *shonen* manga differed in the sense that psychological dilemmas like jealousy were often depicted in *shojo* manga; some say that eyes were drawn larger to make it easier to convey these emotions.

What is the importance of girls' illustrators such as Macoto Takahashi and Yumeji Takehisa?

NI: Yumeji Takehisa took Japan by storm by drawing a specific kind of woman called 'Yumeji beauties': decadent, with big eyes, a bit sad but beautiful. What girls loved most were what we would now call his graphic design works. The stationery, envelopes and *chiyogami* paper he designed were sold in his own shop in Minatoya, which became a place where trends started. Just as girls flock to Hello Kitty today, the girls from the Taisho era were all about getting their hands on these kawaii products!

Macoto Takahashi drew many manga and illustrations that were about ballet or had a very Western European touch. The fashion details weren't always instrumental to the plot, but they made the readers of manga more interested in fashion. While *shonen* manga started to evolve into the action genre, he created works that made the reader pause to admire his stylish illustrations. He worked hard on drawing very feminine characters, and his illustrations are still used today on stationery and other fancy goods. For girls who are into the princess subculture or the gothic and Lolita fashion trend [see Gothic and Lolita Models], his illustrations are iconic.

What is the connection between shojo manga and contemporary kawaii culture?

NI: Early manga artists are still influential now, both directly and in the way that their work has influenced later authors and artists. For example, Junichi Nakahara, who drew illustrations that don't just depict fashion but also overall appearance and lifestyle, still has a shop in Tokyo and his merchandise still sells.

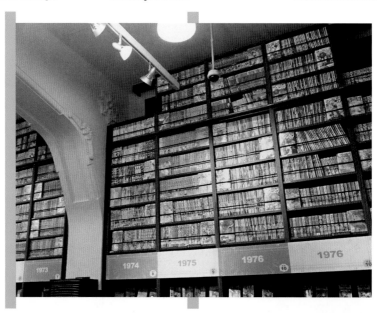

The museum's vast manga collection.

There are specials about him on TV. In addition, he has inspired authors such as the novelist Seiko Tanabe, and has had a strong influence on fashion designers like Jun Ashida, Kenzo Takada and Keita Maruyama. As for manga artists, Riyoko Ikeda, a manga artist who has been active since the 1970s, has also said that Nakahara was a huge influence on her, and the director Momoko Ando has revealed that she is a big fan of the magazine *Shojo no tomo*, which had an exclusive contract with Nakahara. Miyoko Yodogawa, editor in chief of the fashion magazine *Olive*, which is a charismatic publication that creates a very specific vision of what it deems kawaii, was also enchanted with Nakahara's magazine *Junior Soleil*, and has said that it definitely had an influence on *Olive*.

It is likely that Nakahara will continue to influence contemporary creative people in many fields because he drew epoch-making total fashion suggestions featuring Westernized girls. It is safe to say that today's consumers still adhere to Nakahara's great sense of style.

Junichi Nakahara's illustrations of elegant and fashionable girls were popular from the 1920s to the 1940s.

Label Sousou's summer *yukata* inspired by Junichi Nakahara, 2012.

Macoto Takahashi is a pioneering *shojo* manga artist. He began working in 1957, and his images frequently adorned the covers of *shojo* manga magazines such as *Margaret*. Takahashi is known for his dreamy and coquettish starry-eyed girls and princesses, who are surrounded by lace, ribbons, flowers and small animals in fairytale settings. His characters – usually girls in pastel tones, facing front with sparkly, glittery eyes – are loved by Japanese women of all ages. He is one of the most influential artists in creating the sweet Lolita aesthetic, as well as the standard large-eyed look that is prominent in *shojo* manga to this day.

Shojo illustrator Macoto Takahashi, whose work is loved by three generations of Japanese women.

Macoto Takahashi

You are known for your illustrations, but you were initially a manga artist. Do you still draw *shojo* manga?

Only at the beginning of my career. I drew manga for a lot of *shojo* magazines and school magazines, but just for four years. After that, I only did illustrations as opposed to comic-style works.

I contributed to most of the *shojo* manga magazines, and I took a lot of commissions from *Margaret*, although at the time I was doing stories, magazine-opener illustration spreads and covers, rather than manga. From there I started to make products such as handkerchiefs and socks – in fact, everything a girl would use, from panties, notebooks and sketchbooks to bikes.

At that time, boys' things were blue and girls' were red. When I put red backgrounds in behind my girls, I would add flowers and lace to make the background more beautiful and alive. That is why there are so many flowers around the girls in my illustrations, even now.

How do you research your material?

For a theme like fruits and flowers, I look at botanical art and life drawings. The girls are the main subject of my illustrations, so I have to use flowers that complement them. If the flowers are simply drawn from life, they don't suit the girl, so I alter them.

My method is totally self-taught; I have never been to art school. For the rose series, for example, I will plant roses in the garden. Though I don't do sketches per se, I can observe. I see the shape of the stem and how the rose looks when it blossoms, and when the petals drop. The next year, I'll look at sweet peas and watch them mature. If you observe them for a year, you can see their shapes and colours, and how they grow.

Using my observations of lilies of the valley and Icelandic poppies as a base, I can work out how to draw them in a way that suits the girl. I want the viewer to almost be able to smell the rose's scent and feel the texture of the petals.

What other motifs appear a lot?

Instead of drawing just a field, I will put in things like small animals and Japanese white birch to make the forest come alive. There is also the joy of finding these small animals in the illustrations, especially if they are animals that are scared of humans. Surrounding the girl with these animals shows that they trust and believe in her; they see her as a friend. It's great to have that kind of atmosphere in the work.

Are the girls you draw a kind of ideal female?

I don't base each girl on a model or one particular person, but on various people. If I am having a conversation with someone whose hair is beautiful, or I am having tea with a woman and think the way she is moving her hands and fingers is beautiful, I want to draw it. So I collect inspirational things and use them in my work. My girls also have a certain kindness.

How old are they?

They are aged from around 12 or 13 until high school age. At that stage of life, girls have the potential to change as much as their heart's desire, and it is just before they become fully fledged females. Girls of that age have a lot of thoughts and dreams that they can become a princess, or anything they like – that is the most appealing thing about them.

Do you ever draw Japanese backgrounds or do you mostly use European settings?

I have drawn scenes from *The Crane Wife*, *Issun-boshi* and such folkloric tales, but in my work I usually depict foreign girls.

When I was around ten years old, maybe in sixth grade or thereabouts, and Japan lost the war, there was a church with a flower garden in my

Sunny Hill, 2008.

Princess's Treasure, 2010.

neighbourhood. I had never seen anything like it, so I would go there and have a look. When I was watching one day, there was a blonde girl there who was four or five years old, and her mother was calling her.

The girl called out 'Mummy!', and I found that impressive because I had never seen a foreign girl before, and I thought, 'Wow, blonde hair is amazing!'

What do you want your audience to feel when they see your work?

It depends on the audience's psychological condition. If they are feeling a bit blue, they can look at the illustration and think that the girl is saying, 'Try hard to cheer up!'; when they are happy, the girl can be seen as saying, 'It's good that we are both happy!' I never depict the girls laughing or crying: they always have a really ambiguous expression. It's a small smile, kind of like a Buddhist statue, so the audience can feel different things when they look at it.

How has your audience changed over the years?

I have three generations of fans now, and people bring in old products or magazines to my exhibitions. I don't have a singular representative work but everyone knows the style with the starry eyes. Even grandmothers say, 'I had these when I was a child!' Even though all I do is draw girls and princesses without paying attention to trends, perhaps that is a good thing – I was following my own style all this time.

Cover drawing for
Deluxe Margaret
magazine, 1971.

Yumiko Igarashi

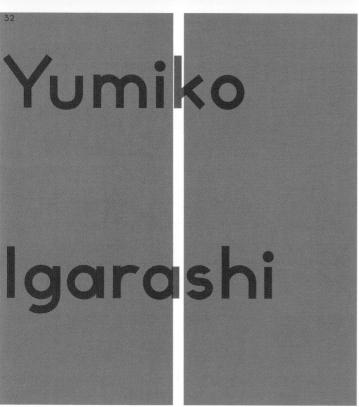

Yumiko Igarashi is one of Japan's most iconic *shojo* manga artists. She is best known for the classic coming-of-age love story *Candy Candy*, which is a staple title for young Japanese girls. *Candy Candy* first appeared as a novel, written by Kyoko Mizuki, before Igarashi rendered it into manga in the mid-1970s; it was then serialized in *Nakayoshi* magazine. The story is set in the early 20th century and depicts a cheerful orphan, Candice White Ardlay, whose optimistic sweetness makes her the epitome of an ideal female character. The narrative follows her as she overcomes hardships and falls in love. It is one of the most revered manga classics of all time.

Manga artist
Yumiko Igarashi.

Was *Candy Candy* explosively popular from the start?

Yes. I think it is because all girls share traits that are depicted in *Candy Candy*. The current generation reading *Candy* and the next will all have things in common, such as their aspirations and their determined, never-give-up spirit. I feel that readers from 30 years ago and primary school students have common ground too. And even if you read *Candy* as an adult, it is quite deep. In the narrative, Candy and Terry break up because of the actress called Susana. I received so many fan letters begging me not to let them separate, but now when I go to signings older women come up to me and say, 'Now I understand Susana's feelings.'

Did you always want to be a manga artist?

When I was in kindergarten, I loved to draw, and I decided I wanted to be a manga artist when I was in high school. Back then it was a fairly mysterious job. There were no how-to manuals, so it was more something that a student who had a knack for

drawing in class would try, but now there are a lot of books on how to draw manga as well as classes you can take.

When I was in junior high school, I was already sending out illustrations to publications. I sent illustrations out twice, and both were accepted.

When you were drawing *Candy Candy*, what was your daily schedule like?

For a manga illustrator deadlines are absolute, because if we miss them, the readers won't get to see the work. Sometimes, in order to meet the deadlines, I wouldn't sleep for 72 hours. I was just chugging coffee in order to stay up; if you eat you get tired, so I was only consuming liquids. I wasn't very fat back then! I was doing that for four and a half years while I was drawing *Candy Candy*, but I think that kind of routine is standard for a manga artist. You can't have a nine-to-five schedule. If you are on a wave you can really ride it, but at times I am just staring at a blank piece of paper for a long time.

Candy Candy is a classic coming-of-age *shojo* manga title from the 1970s which is widely read by Japanese girls. The main protagonist, Candice, encapsulates the kawaii spirit of never giving up and remaining forever sweet, even when faced with adversity.

When did you develop your own style?

There are artists like Shotaro Ishinomoto and Tezuka Osamu that I liked ever since I was young. At first I would emulate them, but after that I began to develop my own sensibilities and individuality. I think I already had my own illustrative style when I was in high school. When I look at my old work, I feel it hasn't really progressed since then!

When did you start illustrating ladies' comics?

I did it for ten years. It was a while after *Candy*. There were many regulations in *shojo* manga – for example, the characters weren't allowed to kiss – and after a while I began to find that stifling. I already had kids, but I wasn't allowed to express adult feelings. I felt as though I wasn't being true to myself, and wanted to make more mature work.

What trends have there been in manga over the years?

After computer games became popular, manga really changed. They became more dramatic, but a fantasy element was also introduced – and although that is interesting and exciting, I really like the warmth of social scenes, dining scenes and domestic family scenes, which are less popular now. For example, in *Candy Candy*, Candice returns to the Pony House where she was brought up because she wants to go home. Nowadays, this sense of having a place to return to isn't as common.

How was the industry affected by the improvement in Japan's post-war economy?

At the time a huge amount of animation was being made. When I was in Italy, someone asked me how so many different animations could be produced in a week. Overseas there might be one large Disney production each few years. Some might even take seven years. Japanese production houses busted the myth that animation is something that takes years to make – there is no other country that makes over ten animated films a week!

In terms of the subject-matter, during the economic bubble there were many female protagonists that wanted to be professionals,

or to have glamorous jobs like being a fashion designer, and those kinds of narratives really increased. Now it is more like, 'What does the guy thinks of me?', and the scale is really small. Well, it's not small – understanding people's souls is as hard as doing a large narrative and just as important – but I feel as though girls are only interested in guys' opinions lately.

There are a lot of people who wanted to become a nurse because of Candy, so when I go to hospitals they really love me. In the same way, I think that many girls want to become a fashion designer after reading fashion designer manga, for example.

Besides other manga artists, where do you get inspiration from?

From films. I get a lot of ideas from films for things like the composition of the background, if I should have the reader looking from below or above, and how it changes the atmosphere to introduce a person into the cell. We can express a psychological state through the depiction of

the landscape and the character, even if nothing is being said. For example, from the reader's perspective, even if we can't see what is on the other side of a door, we might be able to sense that someone is there. The artist has exactly the same perspective as a director.

What is the basis of good manga?

It should appeal to a wide age range, so kids and their parents can both read it, with common subjects that they can both empathize with. But drawing manga is really difficult, so I feel that all manga are worthy. The amount of energy it takes to make the manga is the same even if no one looks at it, so I respect every one.

cute

design

overload

In Japan, cute design is so ubiquitous that characters grace the packaging of even the most mundane products. Japanese people love and respect inanimate objects, as is evident in their traditional rites and festivals: for example, in the blessing and burning of unwanted kokeshi dolls at Shinto shrines (see Kokeshi in Naruko Onsen) and the annual Hari-kuyo festival, which commemorates broken sewing needles.

Kawaii product design formally began in 1914, when Yumeji Takehisa opened a stationery shop in Tokyo that sold fancy goods to upper-middle-class girls. When Japan entered the economic bubble, women's spending power increased and *shojo* manga culture flourished. As the kawaii product industry eventually became based on mass-produced kitsch, it emerged unscathed from the resultant recession. Moreover, the love of kawaii started to transcend age, as older women and men began to customize their mobile phones with numerous charms.

There are three main facets of kawaii design: products based on manga or anime characters; non-commercial design (for example, kawaii construction barriers in the shape of frogs); and companies that create their own characters, such as San-X, Sanrio and PostPet. San-X has created a multitude of products featuring Rilakkuma, their floppy bear character, including stationery, electronics, umbrellas, air fresheners and kitchen appliances. It even became fashionable for girls to wear Rilakkuma costumes on the streets of Shibuya in Tokyo (see *Kigurumi*). Kawaii characters are also adopted by businesses and organizations. The police force, the Army and even Hamaoka Nuclear Power Plant all have their own adorable mascots.

If there is one character that is synonymous with kawaii around the world, it is Hello Kitty, the bulbous-headed, mouthless feline with a cult following. Hello Kitty was created by Sanrio in 1974. The company's founder, Shintaro Tsuji, has emphatically stated his love of the happiness which gift-giving can bring. To that end, his company has a line-up of over 4,000 cute characters emblazoned on countless products. Hello Kitty outshines them all, and her face can be seen on over 50,000 products – everything from plasters to frying pans. She is one of the major attractions at Sanrio's theme park, Puroland, which welcomes over 1.3 million visitors annually.

Kawaii is a constantly evolving concept and has splintered in various directions. Recent permutations that include elements of horror or creepiness now rival the orthodox kawaii aesthetic in visibility. However, there is one central tenet to the kawaii philosophy that all designers agree on: a design *can* be too cute. Japanese sensibilities, imperfection and asymmetry are what makes something kawaii, while items that are self-consciously cute and flawless are solely for children and can create unease.

Clockwise from top left: These soft blocks feature design company San-X's most popular characters like Tarepanda and Rilakkuma.

Even construction barriers in Japan are cute! These pink bunny barriers are located outside Shinjuku station.

Nameneko features delinquent kitties dressed in Yankee motorbike clothing. Here, they are parodying the traditional *manekineko* cats that are thought to bring fortune and customers to shops.

Fake fur bag by design house Swimmer.

Hello

Originally nameless, Hello Kitty was created in 1974 by Sanrio designer Yuko Shimizu and was initially depicted with a bottle of milk and a goldfish. A little later, she appeared with items that girls wanted at the time, such as a grand piano or a teddy bear. Eventually, she was given a background narrative: fans learned that her real name is Kitty White and she lives with her parents, George and Mary White, and her twin sister, Mimmy, in London (since, at the time she was created, British culture was seen as the epitome of cool in Japan).

Apart from this information, her background has been kept fairly vague. We know that Hello Kitty has a pet cat and hamster and eventually even got a boyfriend called Daniel in the 1990s. Hello Kitty's love for her mum's apple pie and the fact she is said to weigh the same amount as three apples has made her even more lovable, yet she has maintained her air of ambiguity. Her appeal is truly international in scope, and she even once instigated a riot at a Singapore McDonald's when fans clamoured for a promotional toy.

Hello Kitty remains fresh by constantly adopting new themes. She has collaborated with brands as wide-ranging as Stussy and Swarovski and even has her own theme park in Tokyo – Puroland. In 1982, her black outline disappeared and by 1997, computers were used to design her, but much of the process can still only be done by hand. And no matter how many characters come after Hello Kitty, she is still the ruling princess of kawaii.

Kazuo Tomatsu, *PR, Sanrio*
Kazuhiro Manabe, *PR, Puroland*

How did Sanrio start?
KT: In 1960, the president and CEO, Shintaro Tsuji (who still holds this position), retired from his job at the Yamanashi government office and went to Tokyo to establish an independent company. At first, he only had four employees, including himself, and was initially dealing in miscellaneous general goods. After that, he began making and marketing goods with characters that Japanese illustrators and designers from outside the company had designed. During the 1970s, a company shop was developed, and characters began to be conceived in-house.

What was the initial reaction to Hello Kitty?
KT: The first products were sold in March 1975, since the product planning and manufacturing takes a while. We made five other varieties of small vinyl purses at the same time with the same shape as the Hello Kitty design, but Hello Kitty sold outstandingly well.

Can you comment on Hello Kitty's lack of a mouth?
KT: It is not that Hello Kitty doesn't have a mouth, it is just that she doesn't have a mouth drawn in. Hello Kitty can talk and sing, of course! We consider this one of the reasons she is popular.

Besides Hello Kitty, who are the most popular characters in the Sanrio line-up?
KT: To date, Sanrio has created approximately 450 characters. With the exception of Hello Kitty, their relative popularity is different in each region and country.

Kitty

In Japan, characters like My Melody, Little Twin Stars, Cinnamoroll and Jewelpet are also popular.

How has the design of Hello Kitty changed over the years?

KT: We are always adding new designs. The ribbon on her ear changes to a flower or other things, or she might wear fashion glasses [with no lenses] or appear in profile. You can see each year's designs on Sanrio's website.

How many new characters does Sanrio release each year?

KT: Lately, around two or three.

When did Sanrio Puroland open, and what is the concept?

KM: Sanrio Puroland opened on 7 December 1990. The theme is communication.

How many people visit Puroland?

KM: Currently, 1.3 million people visit Puroland annually, mainly from within Japan. However, the number of visitors from other Asian countries increases every year.

Is it true that people get married there?

KM: Yes! Every year, between ten and 20 couples hold weddings or receptions at Puroland.

Colourful kawaii fashion label galaxxxy's Hello Kitty collaboration.

The Hello Kitty suite at Lotte Hotel in Jeju, South Korea, shows the popularity of Japanese character goods, which is evident all over Asia.

A Kitty-themed stove in Kitty's house at Sanrio Puroland, a theme park in Tokyo that attracts fans of Sanrio characters. Hello Kitty is actually said to be British, rather than Japanese, so her house is made to look like a mansion in London.

Furniture inside
Hello Kitty's house
at Puroland.

The exterior of
Hello Kitty's house
at Puroland.

EVA Air's Hello
Kitty plane, which
has routes between
Japan, Hong Kong,
Taiwan, China,
Korea and Guam.

The Hello Kitty collaboration from Lolita fashion brand Baby, the Stars Shine Bright.

The Hello Kitty suite
at Lotte Hotel in
Jeju, South Korea.

San-X

San-X is the producer of some of the most iconic kawaii characters in Japan. It has had a slew of hits ranging from Tarepanda, an unenergetic, floppy panda, to the ubiquitous Rilakkuma, a nonchalant bear with a zip on his back. The company has created over 800 characters, including Mikan Bouya, Kogepan and Afro Ken.

Tomoko Kirino, *Public Relations, San-X*

Absolutely anything can be made into character goods, as demonstrated by San-X's catalogue, featuring fans, AC adaptors, chopsticks, golf balls and even buses.

Far right:
Rilakkuma the dopey, floppy bear is one of the most popular Japanese characters.

When did San-X start?
In the early 1930s! Originally we were a stationery company that had nothing to do with characters; we made letter sets and things like that. We then imported some designs from overseas and decorated our stationery with them, and when that sold well, we gradually started to design our own characters and make them into products.

To what do you attribute the characters' popularity?
I think it was partly luck, and also the nature of the market at the time. Also, the designs might have coincided with what customers wanted. With Tarepanda and Rilakkuma, you can get a feel for the characters when you hear their names, which are both Japanese plays on words: Tarepanda is a *tareteru* [droopy] panda; Rilakkuma is a bear that is *rilakushingu* [relaxing]. But when you see the actual image you might be a bit surprised. It is fun and mysterious. Also, Rilakkuma has a zip – although what he is concealing inside is a big secret. These little details are appealing and make certain characters very popular.

Who are your most popular characters now?
Sentimental Circus. The characters are a little strange and have darker elements. There is a narrative to them: they are toys that have been thrown away, but they fix their bodies themselves and perform in their own circus when no one is looking. The lion removed his own tail and gave it to another animal. He can also remove his mane and jump through it, like a hoop. The ringmaster character fixed half of his body himself using different materials.

What is the inspiration behind some of these characters?
The creator of Tarepanda was constantly exhausted. She had a job in which she had to make panda character stickers, and she was so spent she just doodled a floppy animal, but the result was quite interesting. We initially used that image on small stickers and gradually it led to a lot of products.

In terms of inspiration, generally we look at magazines and the media, but we also observe the people coming into our shops and take note of what they are wearing

Arcade games often instigate new character crazes.

and have hanging off their bags, what they are talking about and reading. Also, the staff actually really like these kinds of cute things, so they are just making items they want to own themselves.

You create a lot of animals without mouths. Why?

If there is a mouth, then there is an emotional expression. Rilakkuma has a mouth but he is devoid of emotion, so you can interpret him how you want. It is easy to look at Rilakkuma whether you are happy or sad; if he had a beaming smile, you might reject him if you were feeling blue. These kinds of ambiguous expressions are popular in Japan.

What do you think are the traits of cuteness?

The common answer to that is that when the head is big and the position of the eyes is low, the proportions are like that of a child, and humans are wired to think of that as cute. In terms of our products, something is cute when the concept is really strong, or when there is a story behind the characters, a narrative that allows for variations – lately, I have begun to think that that's indispensable.

Shappo is a character from Sentimental Circus, one of San-X's most popular series, about a group of abandoned toys that get together and put on performances in the middle of the night.

靴下にゃんこ

毎日なんだかシアワセ

♪

トヤヨシエ

こんな
にゃんこがいたら
くらしたい。

本当に靴下をはいているネコが、ある朝部屋にやってきた…。
にゃんこが教えてくれた大切なものって？
すべてのネコ好きに贈る、ほのぼのにゃんこキャラブック。

主婦と生活社

Top right:
**Kutsushita
Nyanko is another
popular character
product line from
San-X. Books and
manga based on
characters can
also end up as
bestsellers.**

What helps to elevate the status of a character?

It's hard to say overall, but recently it is the Internet. If a character becomes a topic online, or a famous blogger introduces it, or an amazing YouTube animation is made of it, that really helps. Celebrities are also influential, but they are certainly not everything.

Why are cute things so popular in Japan?

I think it has been around since the Edo period, actually. Also, there are a lot of obsessive people. If a cute character comes out, a cuter character comes out that everyone wants and so on, and because of that, the customers get passionate about the products. There are also a lot of people who aren't quite on the collector level, but are one notch below that.

How often do you produce new characters?

Once or twice a year. If you keep sending out a lot of characters, the shelf life for each one becomes shorter. We take good care to nurture them and introduce them to the world properly.

PetWORKs

PetWORKs is a small prototype design company that makes everything from anime-inspired hang-gliders to the popular Odeco-chan dolls. Their projects enable concepts previously seen only in science fiction anime to come to life. One of their most famous characters is Momo, a pink bear featured in PostPet, a kind of email software that was invented in the late 1990s. With PostPet, Momo and friends act as postmen and virtually carry mail to your friends' inboxes.

Namie Manabe, *Manager, PetWORKs*
Kazuhiko Hachiya, *Designer, PetWORKs*

Designer Kazuhiko Hachiya with his popular character Momo from PostPet, the email software he designed.

What is the PetWORKs concept?

KH: It is a prototyping company. We make three things: aeroplanes, dolls and software. We have ten people in our company. Normally small companies just do what they specialize in, but our company lets each individual do what they want. In our hearts we are amateurs and always take into account the perspective of the user, but the products are made professionally.

How did you start making planes?

KH: The manga artist Hayao Miyazaki wrote a manga and anime called *Nausicaa: Valley of the Wind*. The protagonist, Nausicaa, flies a plane called *Mowen*. I have been making planes for eight years; *Open Sky* is a real working model of that plane.

Is there anything particularly Japanese about its design?

NM: The Japanese are quite good at making compact, personalized things. For example, so far as planes are concerned, if you want something that can travel faster and higher, leave that to America and Germany. For something

more compact, *Open Sky* is the Walkman of the plane world.

Also, Japanese people like craftsmanship rather than fine art or conceptual art. I think that in Japan the notions of art, design and entertainment are quite close to each other and I think things that have all these functions are commercially viable.

What is the concept behind PostPet?

KH: We wanted to make PostPet a game that you don't have to play. In games like *Final Fantasy* and *Dragon Quest*, there are some tasks that take 100 hours. Games that are meant to be for fun suddenly impose these kinds of obligations on the player. We wanted to make something that was in between a game and a tool.

With PostPet, when the character comes over, you can pat it, but you can also punch it! But if you do that, the pet reports it to its owner: 'When I went to Hachiya's, I got punched!', and then the owner goes, 'What!?' And you might get into trouble. Using text, we can transmit pain.

Why do you think PostPet was so successful?

KH: At the time there was no mail software that was really cute. And it was good timing, with the rise of the Internet. I think we made it with a sense of hospitality and kindness. Inside one of the earlier software boxes, when software was still expensive, we would provide two packages so you could give one to a friend.

In Japan, if you make a product cute, does it sell better?

KH: Actually, it's more important not to make it too cute. Japan has too many cute things, so it is better if you make something a bit scary rather than just adorable.

NM: I liked Dick Bruna's Miffy, who has no expressions per se – it is best to make things around that level of cuteness. It's cute but as a design it is cool-looking too.

Where does Japanese doll culture come from?

NM: Barbie came first, and then a more compact doll called Licca-chan was developed that would sit in the palm of the Japanese hand,

Besides making character goods, software and anime-inspired glider planes, PetWORKs also have a successful doll division.

and fit in typically tiny Japanese houses. Barbie was actually made in Japan because at the time it was cheaper to produce her there.

Momoko dolls are not necessarily for children, but appeal to adult collectors as well. The clothing is miniature, but a lot of attention is focused on the detail.

Do you design all of the clothing as well?

NM: Yes. I do most of the designs but I also work closely with the staff. I am inspired by the season's fashion collections and select the clothing that I would want to wear if I was younger. These dolls look good wearing anything. I also like kimonos.

Are the proportions the same as those of Western dolls?

NM: We use Japanese models as a base. The lines are a bit curved, although the manufacturers really find it annoying because it's easier to make straight things. The breasts are not too big but aren't totally flat and the face is slightly Asian, so the doll is popular in Korea and China as well.

Compared to Barbie, the ideal proportions are quite slim. Our dolls are not curvaceous like Barbie, but below the knees they do not have Japanese proportions: their shins are really long!

Where do you make the dolls?

NM: The idea of making something by hand is decreasing, so we like to work as much as possible with craftspeople in Japan. The old factories still exist in Japan, so we try to make things there, even though it is more expensive. The outfits, however – for products of this size we have to get young ladies from China or Vietnam with great sewing skills and tiny hands!

Kazuhiko Hachiya also makes glider planes inspired by the anime film *Nausicaa: Valley of the Wind* by Hayao Miyazaki.

56

KH: Large mass-production companies like Sony factories go bust and go overseas where it is cheaper, until we get to the point where there are no more LCD TV factories in Japan. However, we try to do things like prototyping, for which you don't have to make huge quantities, within the country – otherwise the skills to make things will disappear.

What is the basis of good design?

KH: Love. Cool designs and exteriors are fine, but if you buy a product and find out that it is actually mediocre, then that is no good. The best products are those which are not instantly likeable, but you gradually fall in love with them. Perfect things like Philippe Starck's designs can be difficult in that regard! We try to make products with a hospitable and kind feeling to them, products that you grow to love by using. Things with a gap or imperfection are charming, and things you want to keep close by you.

With dolls and 3D computer graphics we make sure there is some asymmetricality or easiness, as human bodies aren't exactly symmetrical. When we see things that are perfect, we perceive them as being cold.

PostPet is a software program that enables characters such as Momo to virtually carry your mail to a friend's house, turning email into a kawaii game.

Doll designed
by Namie Manabe
from the PetWORKs
doll division.

Gloomy

In Japan, popular kawaii characters are often a bit creepy or odd. Gloomy Bear falls into the *guro–kawaii* (grotesque cute) category. While he has all the traits of cuteness – a big, round, pink head and an adorable face – he also has homicidal and predatory urges. Often depicted splattered with blood and attacking his helpless owner, Gloomy is a huge hit with visual kei fans (who dress up in elaborate costumes and make–up), goths and the Japanese maid subculture (see Maid Cafés).

Mori Chack, *Designer*

Bear

Designer Mori Chack at his Akihabara home.

How did you start making goods?

In the beginning, I was selling drawings and postcards on Shinsaibashi-suji street. It was an area where many artists like myself would sit, lined up, and try to sell our work.

Is it difficult to survive as a freelance character designer?

Yes, a bit. Most of the popular characters are affiliated with large companies and are designed by their in-house designers, rather than independent designers like myself.

Was Gloomy your first hit?

Yes, but Hanyo Usagi, the rabbit with the long ears, is as popular as Gloomy now.

Is there a message behind Gloomy?

I was watching the news and there was an incident where a bear emerged from the forest and attacked a human, and I thought 'Oh! Bears are actually quite terrifying animals!' Usually, bear characters are simply cute and fluffy but in reality, they are much stronger than people. If you actually met one, it would be quite frightening, and I wanted to put a sense of that terror in the cuteness. With the rabbit, everyone says rabbits are cute, but in reality they are used for experiments by humans.

What kinds of people are Gloomy fans?

Visual kei bands and their fans. Goths, punks and rockers. The people that like my work, and the mainstream that like Hello Kitty – their perspectives are a bit different. I am trying to appeal to the minority.

What is the girl/boy ratio of your fans?

There are probably more girls, but perhaps compared to other characters the ratio of guys is much higher.

Do Japanese children generally have teddy bears?

Yes. Everyone has stuffed animals, and not just bears. I had pandas and a chimpanzee.

What kind of manga did you read as a child?

JUMP magazine. When I was in junior high school, I just read the regular manga that everyone was reading. I also watched *Chikichiki machine* [*Wacky Races*] and *Tom and Jerry*. From our perspective, Western products seemed cool.

What happens when you do a collaboration with *Pink Panther* or *Hello Kitty*?

Depending on the character, there are parameters within which we have to work. I did Hello Kitty three or four years ago and they had a problem with the blood,

Gloomy is a violent pink bear popular among kids involved with subcultures.

Hanyo Usagi is also very popular. She is said to be the result of artificial cross-breeding and hence has ridiculously long ears.

While bears are commonly depicted as docile and friendly, Gloomy is often shown attacking his owner.

so that ended up being tomato sauce. With Disney, there were a lot of rules in terms of the angles of the figures.

What kind of things don't appeal to you, in terms of design?

I am not interested in just drawing cute characters; I want to make something that makes your heart jump.

Why did you make Gloomy pink?

Originally I made pink, aqua and black versions, but gradually it got filtered down to pink. Pink would never normally be associated with sadism and violence, so it's really perfect.

Kigurumi are mascot costumes that often resemble anime or manga characters. Overseas, mascot outfits are associated with places like Disneyland and amusement parks, but in Japan, they make an appearance everywhere: anime fairs, events, concerts, fashion shows and shop openings. In fact, the presence of a Hello Kitty *kigurumi* mascot can be a draw to an event. Marble Mascot make *kigurumi* suits that represent generic animal characters and are ridiculously cute. The love of mascots in Japanese culture is also an extension of cosplay culture, as people obsessed with these outfits will wear them to underground clubs.

A more casual form of *kigurumi* that look like pyjamas or onesies, particularly the Rilakkuma and Pikachu varieties, became a hit with Shibuya girls, who wore them around the streets of Tokyo, often paired with an over-accessorized mobile phone.

Kigurumi

Marble Mascot make their own original character *kigurumi* to be worn at parties, fairs and shop openings, and even as fashion.

アンパンマ

Anpanman is a
popular children's
anime character.
Official mascots
from TV shows,
manga, anime or
character goods
companies are
an attraction at
shop openings,
conventions and
events.

Marble Mascot
kigurumi.

Swimmer is a hugely popular design company that has 41 shops all over Japan, and is loved for its retro-kitsch style. It makes everything from kawaii kitchen goods to sneakers, inflatable swimming rings, umbrellas, scissors decorated with mushrooms and toilet brushes in the shape of ice cream cones.

Hiroko Sakizume, *Designer, Swimmer*

Right: One of the Swimmer staff in her over-embellished bedroom.

Swimmer

How long have you been designing goods for Swimmer?
I have been at Swimmer since I graduated from high school in 2000. There are a total of 20 designers … and they are all girls!

How have your designs changed over the years?
Before, I was just getting things out there with a kind of energetic gusto. My designs have much more thought behind them now, but that can be good and bad, actually.

What kind of motifs do you use?
Rabbits and cats and things like the characters in *Alice's Adventures in Wonderland*. I like the story – it is really strange. I like her as well, and also her clothes; I find her really kawaii.

Are you influenced by the manga you read as a child?
There is a manga artist who works for *Nakayoshi* magazine, Yoko Matsumoto, and her work is incredible. She creates suspense and ghost stories, but the main female character is really cute. I like the stories too; when you are young, you like scary things.

Did you collect products as a child?
I really love Koeda-chan, which is a plastic tree house for children. I don't like the new versions so much, but the vintage ones are great. It's not too cute; it's just cute enough. I aim for that as well.

What is the process like when you make a new product?
I just draw without thinking. If I'm thinking of drawing a rabbit, sometimes it ends as up a dog.

So as a designer, you can do what you want in this company?
Yes. Each individual designer decides what she wants to make, and oversees the entire design process for one product. It's ideal, but it's also a lot of responsibility for one person.

The Daikanyama Swimmer store; downstairs there is a café that sells kawaii panda-shaped cakes and cookies.

Usually, in large companies all the designers give their opinions and make collaborative designs, and the result tends to be unadventurous products, but with our company, if the designer wants to make something, and the boss approves, it goes ahead. There is a kind of individualistic passion for the work.

When did Swimmer start?
It started in 1987 as a ceramics shop and the current boss made it into a goods company. The shop in Daikanyama started a year later. In the beginning, the products mostly had a 1950s Americana look, but the aesthetic changed according to the designers, as the company tends to leave things up to them.

How has the company changed since the 1980s?
In the 1990s, it had a classic British-looking feel; we had adult-style bags and umbrellas. But in the late 1990s, two new designers came in and it became more pop. Around that time kawaii and the princess look – frills, lace and pink – came into fashion.

Since when has kawaii been such a big thing?
There has always been kawaii stuff but now it's not embarrassing! It was around five years ago that genres like *hime-kei* [princess girls] and *mori* girls [lit. forest girls, more earthy] emerged. Before, it would be remarked on if an adult had cute things, but in the last five years it has become totally acceptable for grown-ups to have over-the-top nails and decorated mobile phones, almost to the point where it's too much.

Within that craze, what about the cuteness of Swimmer makes it stand out?
It depends on the individual designers, but I also think that we don't make our products too over-the-top; we have some restraint. I think the company as a whole has that kind of sensibility.

Bukkoro

Yukiko Yokoo is a graphic designer who fuses traditional Japanese motifs together and gives them a pop makeover. Her images are laden with cute characters such as ninjas, sushi with legs and pink deer, and reference classic Japanese card games, kimono patterns and temple art.

Designer Yukiko Yokoo outside her house.

How did you get into design?
When I went to university I specialized in design, but it was advertising design. I developed an interest in game and character design halfway through, and after graduating, I started working at a gaming company. After eight years there, I designed *Taiko no Tatsujin* [a taiko drumming computer/ arcade game], and my style developed from that point on.

What kind of game design were you doing?
I was making realistic-looking fighting games like *Tekken* and was in charge of the 3D graphics.

When you started to make graphics for games like *Taiko no Tatsujin*, what were you influenced by?
Initially by Dick Bruna's Miffy; those lines and solid colours. Recently, my work has become more patterned and layered, but when I was starting I used a more simple style, with black lines and black eyes, which I think is a result of being influenced by Bruna.

What aspects of your work are Japanese?
I am conscious of how foreigners see Japan. I find this perspective interesting, so I live in an old traditional house and collect things like kokeshi [traditional wooden dolls] and *ema* [wooden talismans], and even things like plastic bonsai trees. I love the patterns on kimonos and traditional paper, the composition and colouring is great, and I want to show these things in a more pop style. However, I also love the work of tokidoki [see tokidoki].

Why do you think the kawaii-style things that designers from abroad make are so different to Japanese kawaii?

I think foreign kawaii is really individualistic. It is hard to put into words why, but the atmosphere is different, as is the perspective and the way they draw faces. I think Japanese people have been surrounded by small, cute, round things since they were young and it seems natural that these things exist in Japan, whereas foreigners prefer things to look more realistic. For example, in games, foreigners find cute things a bit strange, or immature-looking. Lately, however, cute things have become more popular overseas, even among adults.

What do you find interesting about traditional Japanese aesthetics?

When you look closely, you can really sense a pop atmosphere. I didn't notice when I was young, but it can be seen in the use of things like gold on temple decorations and the pastel in designs. I feel that, in general, using traditional elements and refiguring them in a pop way is quite common nowadays, although that wasn't the case when I started designing.

What are your favourite motifs?

Food. I love to eat, which is one of the reasons I can't leave Nakano.

What makes something cute?

The thing that makes something cute is the roundness. It's hard to say overall, because what people might consider cute depends on the individual, but things like kokeshi dolls seem cute to me now. I think maybe there are too many things that are too cute in Japan now, so people are attracted to more subdued cute things like kokeshi.

OMIGOTO! SUSHI no TAKINOBORI (Excellent! Waterfall of Sushi), 2007, digital image.

RABUROU!, 2007,
digital image.

BONSUWARU
(Bonsoir), 2009,
digital image.

Nameneko is a group of four delinquent kittens who wear a variety of rebellious outfits, such as leather jackets. They are photographed smoking in the bathroom, playing in a rock band or with their motorbikes. In the early 1980s, Nameneko was the most popular animal product brand in Japan, garnering 100 billion yen in revenue in two years for over 500 types of items. They even appeared in *Fortune* magazine.

Satoru Tsuda, *Designer*

Nameneko

How long have you been designing?

Since I was 19 years old. I failed my university entrance exams so started doing part-time work, but was astounded by the low pay. I thought, 'I really can't be doing this.' I wanted to sell posters in Japan, and I imported them from the UK and America. They did so well that I ended up designing my own posters and calendars. At the time there was no notion in Japan that posters were something you would buy. Once, when I was in a record shop, I overheard a girl saying, 'I would even pay for that poster!' Out of everything that appeared on my posters, the two things that sold astronomically weren't Marilyn Monroe and James Dean, but cats and cars – they sold 100 times as many.

And how did you end up with Nameneko?

When I went to eat lunch one day, the cleaning man had a cardboard box on the back of his bike. I asked what it was, and he told me they were born under his flat so he was going to throw them away. I asked for them, even though I had no idea what kind of animal

Nameneko designer and photographer Satoru Tsuda outside his office.

they were. When I opened the bag, they were so small, just born. They had their eyes closed, they were wet and had no energy and I thought they would surely die. I took them out, washed them with gauze and dried them with a hair dryer. When they fluffed up, I realized that they might be cats! I washed them and put them in a basket and took them to work. Then they started to think I was one of their parents. When I lay in bed, they would jump in.

This is kind of gross but when I went to the toilet, the smell would stimulate them to go as well – and all four of them would want to go to the toilet too. They quite often fell in but over time they became good at it. When I saw this I gradually fell in love with them.

When you took the photos, how old were they?

One and a half months to two and a half months. We did all the shoots in one month. My girlfriend at the time designed outfits for French dolls. One day she left the dolls' clothes at my place and the cats played with them until they were wrecked. I thought, 'This is the end', and I made the cats wear them and took some snaps. I showed my friends and they said, 'These will sell!'

So are the cats' outfits actually dolls' clothes?

Yes! They were worth 150,000 yen, the same price as an Armani suit at the time, and they were all hand-sewn. For the kimono shoot, because the patterns on human kimonos are much too large, we had to make some out of handkerchief material.

What else were you selling?
520 different items. There is nothing we didn't make! Bikes, games, the Nameneko record which went to #1, a manga, ads for Microsoft ... I wouldn't have imagined we would fit the image of a company like Microsoft!

Who were your clients?
Female office workers bought the stationery, and it spread straight away via word of mouth. The people that buy Nameneko items are not necessarily cat lovers though. I sold over 10 million products – that means everyone had some.

I think one of the reasons we did so well is because we used a catchphrase. *Namennayo* [delinquent slang roughly meaning: don't treat me with contempt] is a feeling that everyone has about their parents or teachers. Another reason it succeeded was because as many boys bought the products as girls, whereas *Gundam* and Hello Kitty are more gender-specific. Also, the cats are really handsome.

How did you get them to stand up?
Actually, they are sitting. It just looks as though they are standing. I tried to shoot other cats, but I could only do it with these four. So all the products and photos are of these four cats; we just changed the styling.

tokidoki

tokidoki means 'sometimes' or 'occasionally' in Japanese. It is also the name of the company of LA–based Italian designer Simone Legno, whose visual vernacular is steeped in kawaii. His motifs reference various facets of Japanese culture from traditional to modern, such as slender tattooed vixens, ninjas, Godzilla and Tokyo, yet his work is more than a direct copy of Japanese aesthetics. It displays a playful fusion of Western and Japanese sensibilities, mixing Italian chic, Japanese cute, Americana and street culture to create something entirely unique.

When did you start to develop your signature style?
I have been drawing characters since I was a kid. It might have been the heavy influence that Japanese anime and TV shows had on Italian children in the late 1970s and 1980s. When I started to learn to use design software at school, my goal was to redesign the kimono-wearing girls of Japanese woodblock prints using computer vectors. After that, I realized that what fascinated me was not just Japanese traditional art, but the cute characters you can see everywhere in Japan.

I decided to make the traditional-looking kimono girls and kawaii cartoon characters coexist. Eventually, the kimono girls became girls in contemporary fashions, with tattoos and coloured hair that pay homage to my punk rock background. That's why lots of my characters are edgy and rebellious. Moving to LA brought a lot to my artwork. I was immersed in a very unique street culture. My characters gained a lot of street attitude. For example, I have a gang of lions covered in bling, bucks and guns.

Simone Legno is the Italian-born, LA-based designer behind the tokidoki empire. He fuses Italian chic, Japanese pop and LA street style to create a unique aesthetic that is loved by all the cultures he draws from.

When I design a cute face, even if I want it to look Japanese, it comes across as different. The elements of daily life that I grew up with are different from the ones in Japan, so in my work it's normal for a character to ride a Vespa, eat spaghetti or run after a soccer ball instead of eating a rice ball, doing kendo or wearing a school uniform.

How did tokidoki start?

tokidoki started as my website, where I promoted my professional skills right after design school. It was a very experimental Flash-animated site, full of characters, colours and games. The traffic grew very fast, up to 20,000 people a day. One day, my two current business partners [Pooneh Mohajer and Ivan Arnold] saw my work and fell in love with it! They proposed a partnership and we founded tokidoki as a brand, and I moved to LA for this new adventure.

While Legno's designs can be seen on bags and clothing, he is perhaps most loved for his kawaii toys.

In what ways were you influenced by manga and anime?

In kindergarten I was already drawing manga. I was very inspired by Japanese anime. It was not just the character design and the stories; through it, I could see Japan's society and lifestyle. I could see the house where Doraemon lives, I could see the student classrooms in *Lamu* (*Urusei Yatsura*), the trains in *Ganbare Genki*, oden in *Ashita No Joe*, rice balls in *Trider G-7*, the fascinating kanji writings on walls, the architecture, baseball fields, schoolyards and so on. During my childhood, it was all right in front of my eyes, even while I was eating pasta every day and kicking a soccer ball in my Rome neighbourhood.

Your work would be described as kawaii in Japan. Why are people so drawn to this aesthetic?

I think it's because the feelings and message are simple and instinctive, but strong, pure and direct, like the language of kids. Kawaii stuff is easy to understand and to absorb because it is not challenging. It makes you smile and you just want to own, protect and cherish it. The aesthetic also has a lot to do with youth and always has a fun, whimsical spirit.

To what do you attribute your global success?

The fact that tokidoki is genuine and unique. It is not designed with the intention to create the next thing on the market. tokidoki is a mix of Western and Eastern culture. It is positive, cute, edgy, fun, sophisticated and silly at the same time.

tokidoki's huge
installation at
the K11 shopping
mall in Hong Kong
for the Food Art
Festival.

Street

In Japan the streets are laden with street signs, construction barriers and mascots which are absolutely adorable. Even signs that warn of tsunamis and earthquake damage feature cute characters.

A series of fruit bus stops in the city of Isahaya in Nagasaki Prefecture.

Cute

MonsterGirls, created by Shigetomo Yamamoto, are creepy cute characters drawn with bold lines that mix punk and manga aesthetics. Originally a street artist, Yamamoto designs characters in a way that is close to typography, often with a set shape or pose. Together with Yumiko Yamamoto (see Otome Kokeshi RIBBON), he runs a shop filled with kawaii items acquired while travelling.

MonsterGirls

Who is the main MonsterGirl?

This girl is a mushroom! She grew out of a mushroom and she never matures. There is no particular message, but there are many MonsterGirls, not just one. The mushrooms grow in places that girls are interested in, like bakeries that make really delicious cakes or cute bread. The male characters are people working in these shops and end up teaching the girls to bake and so on.

The design itself is inspired by animals, like cats or rabbits. Cats don't smile, although they are not particularly angry either. If a cat is interested in something it looks really intense, and I wanted to express that.

I have been drawing constantly since I was a child, up until high school. After I graduated I went to design school. During high school I was in a visual kei band.

Did you have spiky hair?

It was quite long. But in high school everyone was like that. After that, I produced techno music and we went to Germany and France a lot. I'm influenced by the old German illustrated books that I saw while on tour. East Germany isn't meant to be a particularly joyful place but the things they make are really bright and dolls are made in really garish colours. Czechoslovakia and Poland were also Communist but their dolls look more real, so it is fascinating that the East German dolls are really cute.

Do you think your work is kawaii?

Yes! To say something is kawaii gives it a real power, a kind of motivational strength.

An Osaka girl models a MonsterGirls t-shirt. MonsterGirls have also collaborated with fashion brand Anna Sui.

Monster Girl
CupCake Shop

Why do people in Japan
obsess over cute things?
Maybe because they are childish.
In Korea, although girls are
exempt, guys have to do military
service, so they drop their
childishness from that point
onwards. When they come back
from the Army, they are adults.
In Japan, there is no set time for
growing up like that, so people can
remain kids even when they are 40
or 50 years old.

Paro

Dr Takanori Shibata, the designer of Paro, at his office in Tsukuba Science Centre.

Paro is an adorable robotic harp seal used for therapeutic purposes in hospitals, nursing homes and emergency refuge centres during natural disasters. He has tactile, temperature and light sensors, and sound recognition technology enables him to understand and respond to his own name and simple phrases (such as 'Kawaii!'). Paro reacts superbly to being hugged and spoken to, flinches when you touch his whiskers and blinks when the camera flash goes off. Proving popular and effective among dementia sufferers and children in hospital, Paro proves that cuteness can have healing effects.

Dr Takanori Shibata, *Paro Designer, Tsukuba Science Centre*

the Seal

Why did you use a harp seal as opposed to a more orthodox pet animal?
We could see the potential owner as having the pet on his or her lap while chatting with friends, or they might have it sitting next to them and stroke it while watching TV. If you think of something furry, soft and warm that occasionally moves, a seal is a good choice.

There are two reasons to purchase a Paro: as a pet and for therapy. Dogs and cats are the most common pets, so initially we made them and monitored people's opinions of them. Everyone knows what a cat or a dog is, and they immediately go over and play with them, but they are judgemental – they will say that the robots feel different or that they don't react like real animals, and end up comparing them to the real thing. People don't generally have any experience with seals, so they think, 'Oh, I guess this is what they are like!' And also baby seals seem 'pure'.

Several Paro robots are left at emergency housing and crisis centres after natural disasters.

Lifelike and adorable, Paro is said to have healing qualities that are particularly beneficial for dementia sufferers.

Paro seems to have outstanding results among people with dementia.
With people that have dementia, patients that want to return home or might be violent or shout, you can see the benefits easily. They sit down with Paro and they can relax. Using Paro, therapists can facilitate conversation with people who haven't talked for a long time, and there have been many cases of patients recovering speech functions. Many dementia patients have started to do things they haven't been able to do for a while.

Paro has also been successful with kids that are in hospital for a short time or have autism. Or people suffering a lot of pain, or those who have to take medicine constantly, and can't relax – when they meet Paro they can forget the pain and are comforted.

In the West, caregivers might typically give medicine to problematic patients, which is costly and has side-effects. Moreover, the medicine doesn't generally work straight away so the caregivers still have to keep an eye on the patients. With Paro, although the nurse still has to be there, the patient is calmer. And Paro has no side-effects!

Why do cute things make humans feel better?
It's a really difficult concept, but if you interact with Paro there are a few levels on which you can see results. You can get a therapeutic effect even just by touching and smelling him. Tangible aspects like the warmth, the materials and the weight are important, as they can revive and stimulate past memories. Paro weighs 2.7 kilograms, the same weight as a baby. We aim to recall the memories of women who have had children, and grandparents. Humans have a lot of memories, and interacting with Paro is like going through an old medicine chest with various drawers. The brain is invigorated, and the process is close to reminiscence. Not all memories are good, but by remembering things, the soul may be calmed.

Besides Paro's cuteness, why do you think he has been successful as a therapy pet?
Predominantly the quality – he won't break. When you charge him, the plug is like a baby's dummy, and it seems natural, unlike changing the battery by opening the stomach with a zip. When a person interacts with Paro they might handle him roughly, but we make sure he doesn't break under these conditions. He is safe and dependable, and you don't get sick of him. Dogs live for 12 years, and Paro needs to function and to live with his owner for that long too.

Another reason for Paro's success is that each Paro is handmade, so there are small differences in their faces. When you mass-produce robots it gets a bit scary, but when you see that there are differences between them they seem more alive. Of course, there is a high-tech part of Paro, but that is hidden inside and, because he is handmade, there is also a kind of craftsmanship to him.

Itasha

Itasha is a part of *otaku* (geek) culture in which cars are totally and completely manga—ized by being covered with beloved kawaii anime or manga girls. While 1980s *itasha* consisted of a few stickers stuck on the bonnet of a car, contemporary *itasha* involves full paint jobs on everything from drift and racecars to Ferraris and Audis. The interiors are often customized with tons of TV sets and speakers that light up. Moe Haku is one of the largest *itasha* car shows, and is held at Makuhari Messe International Convention Complex during the summer.

Sexy cosplay girls whose costumes replicate manga or anime characters stand in front of *itasha* cars at the Moe Haku car show, an annual *itasha* convention for *otaku* and fans of these manga cars.

adorable

eats

Japanese cuteness can be seen to full effect in the country's edible treats. Traditionally, aesthetics have played an important role in Japanese foods, from delicate and elegant traditional *wagashi* sweets to *kaiseki ryori* (multi-course haute cuisine), which is superbly designed to appeal to the eyes and reflect the seasons. The influence of *wagashi* sensibilities is particularly evident in many varieties of sweet foods, even Western ones. Japanese designs for cakes, cookies and even macaroons are reminiscent of *wagashi*, which are often made using pastel colours in the shape of animals or flowers.

Nowadays, most contemporary Japanese sweets – such as the chocolate, candies and gummies that are seen at the supermarket – employ kawaii graphics on their packaging. Often, the item itself is shaped in a cute way. Macaroons can't just be round; they must be panda-shaped. For a cake to look delicious, it must resemble a teddy bear. And a cookie seems so much more tempting when it's shaped like a rocking horse!

Cuteness is not restricted to sweet foods. Innovative food design can be seen in everything from sushi to bento lunchboxes, through which diligent kawaii-loving mums let their creativity flow in the kitchen. Large companies also see the marketing strength of cuteness, and use characters in their logos and brand images. Take Kewpie Mayonnaise: while the product itself is undeniably delicious, the brand's advertisements, which feature the creepy cute Kewpie doll army, are legendary in their eccentricity.

If you stroll into a supermarket and look at the overflowing cuteness of the products there, it may be hard to see a connection between chocolates shaped like koalas and traditional food design. However, the notion that food has to beautifully presented has always been a part of Japanese culture. Here, we present some of the most exquisite kawaii eats, from classic *kintaro* sweets to deliriously cute maid cafés.

Top: Cute macaroons from Nihon Royal Gastro Club. According to Ayumi Suzuki at Nihon Royal Gastro Club, 'They are round like macaroons but are baked with a lovable animal character print.' They became a huge hit item for 'White Day', 14 March, when girls are given gifts to thank them for the Valentine's gifts that boys received a month earlier.

Bottom: In Japan, every kind of food can be repackaged in a cute way, even these Odawara fish cakes.

Maid

Maid cafés are something of an epidemic in places like Akihabara, a Tokyo shopping district in which *otaku* culture is concentrated. At these cafés, subservient women in full French maid outfits serve customers as if they are royalty in a private residence. The food – typically omelettes with ketchup splattered on top in the shape of a cat face, or curry served on a pink plastic plate – usually leaves a lot to be desired. However, if you want to be pampered by a doe-eyed waitress who squeals 'Welcome home, master!' and is decked out in the frilliest, most flirtatious dress possible, maid cafés are the place to indulge in your fantasy. MaiDreamin is Japan's most successful maid café enterprise. Founded in 2008, quite late in the craze's timeline, it now boasts 11 outlets.

Miki Ikezawa, *Representative from MaiDreamin*

What is the concept of MaiDreamin?
It's a dreamland that all people, from kids to the elderly, can enjoy.

We have five outlets in Akihabara. The first one was established in 2008. However, the culture started around 2003. There was a TV series called *Densha Otoko* [train boy] that featured maid cafés and helped popularize them. Since then, maid cafés have been for a really specific clientele. We wanted to make them more accessible.

By specific, do you mean *otaku*?
MaiDreamin is for everyone; we have kids, families, junior high school students and businessmen as well as *otaku*. The guy to girl ratio is about six to four. Although everything is in Japanese, because of our Akihabara location we get a lot of tourists from around Asia and France.

What kind of girl wants to become a maid?
Girls that like Akihabara culture, or girls that like the costumes and want to become entertainers. A lot of them are cosplayers in their spare time too, and love photo shoots.

What are some traits that the popular maids share?
The most servile maids are considered the best. Even if they are good entertainers, if they dump a cup on the table with a bang, that is no good. They need to pay attention to the smallest details. On top of that, if they are photogenic, that is a plus. We give them one-on-one teaching, and train them rigorously.

When you interview prospective maids, what are you looking for?
I check to see that they can greet me politely. I need to make sure they make eye contact – if they

can't do that, they're no good, no matter how cute they are. The number one thing is to be aware of the customers' comfort, and then, on top of that, they should have meticulous manners and etiquette. After that, they should be able to do shows and perform on stage.

Why do Japanese people like cute girls as opposed to sexy girls?
They like imperfect things and consider them cute. Instead of admiring a really gorgeous Parisian model, they like Hello Kitty and think she's lovable. I think the attraction of maids is connected to this notion that they are not perfectly beautiful, but they are cute and lovable.

Cafés

Top: Maids at MaiDreamin occasionally sing and dance on stage, and many aspire to be Akihabara idols.

Right: A kawaii maid at MaiDreamin, one of the most popular maid cafés, serves drinks while kneeling in a subservient manner.

Some of the most popular maids at the Akihabara store pose for photos on the main stage, which is also used for dancing and singing. The cute decor, outfits and otherworldly behaviour of the maids makes visitors feel like they have stepped into a manga world.

Maids are trained to display menus, place food and drinks delicately on tables and treat their customers like pampered royalty. While this might sound appealing to men only, many cosplay-loving girls also enjoy the atmosphere.

Mayoko, Kyara Sweets

Bento
Boxes

Mayoko, a mother of two, is a *kyara-ben* (character bento) and *kyara* sweets maestro who has published books of her incredible bento creations. *Kyara-ben* like these are hugely popular among mothers who want to display their creative skills in the kitchen.

Kewpie

Kewpie was the first mayonnaise to be manufactured and sold in Japan. It was first produced in 1925, when Japanese people were not very familiar with the condiment. In order to make it a product that anyone could love, the company included on the packaging an illustration of a Kewpie baby doll, which were popular around the globe at the time. In 1957, the company officially changed its name to Kewpie Mayonnaise, going on to create mind—boggling characters and quirky ad campaigns.

Mayonnaise

An early advertisement for Kewpie Mayonnaise.

Kewpie products are loved and collected by girls.

Tarako is fish roe that is traditionally served with rice. The salty flavour goes well with mayonnaise and is often used as spaghetti sauce. These *tarako* Kewpie dolls are cult items and the TV advertisements featuring them are completely absurd.

Micarina

According to chef Mika Ogawa, 'Micarina sweets want to flutter your heart, with sweets that are cute and delicious, and just by looking at them, you will become content!' After training at Le Cordon Bleu in France, she is now one of the most sought-after candy, cookie and cupcake makers for events, weddings and custom projects.

Sushi rolls don't usually conjure up images of Santa's face, snails, umbrellas, cows and Mt Fuji, but with *kazarimakisushi* (decorative sushi), Japan's latest kitchen craze, it is all about being as creative as possible – as long as you can depict it in a roll.

Go Nakaya, *Branch Manager/Public Relations, Yokohama Kazarimaki School*

Kazarimakisushi is a sushi craze whereby traditional rolls are made into kawaii designs.

When did *kazarimakisushi* start to become popular?
Chef Ken Kawasumi popularized the trend ten years ago, so it's really recent. However, in Chiba Prefecture there is a traditional style called *futomaki matsuri* sushi, which often has egg on the outside instead of seaweed. So this idea of making patterns in sushi has been around since the Edo period [1603–1868]. Chef Kawasumi was a Tokyo-style sushi master, so, using the technical skills he already had, he tried to keep up with the times by making motifs like pandas and lettering.

How do you produce such vivid colours?
Well, we do dye some of the sushi for photos, but a lot of people aren't okay with food colouring, so generally, we use things like *furikake* [rice seasoning] to get the colours. One of the great things about *kazarimakisushi* is that you can get most of the ingredients from the supermarket.

Kazarimakisushi

There is no limit to what can be depicted on *kazarimakisushi* rolls, and most of the ingredients can be found at the supermarket. However, its creators try not to use the colour blue, as it is traditionally associated with poison.

Japanese food designs are often seasonal. This snail motif is only used during the monsoon season to reflect the rainy weather, when snails are most prominent.

What is the appeal of this kind of sushi?

The *maki su* [vinegar] that we use today is slowly being eradicated in Japan because, when we think of sushi nowadays, we think of conveyor belt sushi. We teach *futonomaki*-style sushi, which has traditionally been lauded as a homely taste that brings back memories of your mother's cooking. During the Showa era [1926–1989], Japan was still poor and mothers would make it for special occasions and put in a sweet ingredient. Their children would be overjoyed to have such a treat. Nowadays it is rare for Japanese people to make sushi at home. One significant point is that we teach mothers and young girls to make sushi at the same table, and that is great. It is a form of cultural transmission.

Are the designs seasonal?

Yes. For summer we do crabs, and we make carnations for Mother's Day. In winter we had a Yule log and a snowman. For spring we make cherry blossoms; for the rainy season, snails and umbrellas.

Kintaro

Kintaro Ame Honten is a company in downtown Tokyo that specializes in classic *shibu-kawaii* (simple cute) sweets made of a long roll that can be cut to reveal the face of a character. The pattern changes seasonally, and features pandas, celebrities' faces or the latest manga characters. However, the sweets that are loved best depict the original Kintaro, the protagonist of a Japanese children's folk tale. The shop is in its fifth generation of management, and perfecting the craft of making these sweets can take up to three years.

Akio Watanabe, *Owner, Kintaro Ame Honten*

Ame Honten

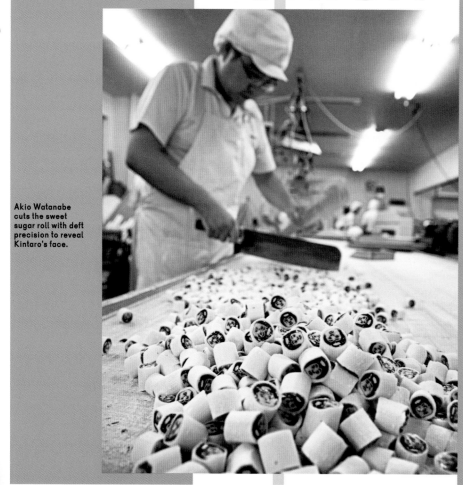

Akio Watanabe cuts the sweet sugar roll with deft precision to reveal Kintaro's face.

How did this company start?

At the beginning of the Meiji period [1868–1912], the person who started the company was selling sweets in a tent. The person who took over from him went to Kansai to learn confectionery techniques and was trained there to make not only round sweets but also sweets with faces and patterns on them. Apparently, there were many people who knew this technique in Kansai, whereas in Tokyo, plain sweets were common. Before Kintaro sweets they were making [folkloric characters] Okame and Fukusuke faces and selling them. After returning from Kansai, the chef started to make Kintaro sweets.

Has the technique changed at all?

They are basically handmade, but if you compare how we make them now to how we used to, things like the tools to boil the sugar syrup have changed. The fire is really strong now, and the temperature is higher. When the syrup is made it is transparent, but when you pull it, it reacts to the air and becomes white, and previously the white would be a bit foggy. Now, when we pull it with a machine, we get a really clear white. Because we use machinery, the face is a lot clearer.

In the past, did you make other characters besides Kintaro?

Although we make various characters and celebrities now and then, if you look at long-term sales, Kintaro is really the most popular. Using the Kintaro face, if we drop the eyebrows it looks like he is crying, and if the brows are lifted he looks angry, so by changing the details slightly the expressions change dramatically.

These Kintaro Ame designs feature traditional motifs: goldfish, turtles, the Seven Lucky Gods and simple messages such as 'Thank you'.

how
to
dress
kawaii

While cute clothes can be found in boutiques in Shinjuku, Shibuya and, increasingly, Koenji, if there is any one Tokyo neighbourhood that epitomizes the kawaii ethos, it is Harajuku. The district is the undisputed street fashion mecca of Japan, and feels like an open-air gallery of unique style. Historically, it has been a playground for young people who wanted to escape the rigid norms of Japanese society. Though the punks of Harajuku hardly have a political agenda, they feel that fashion is a means of expressing anti-conformist sentiments in a society where heterogeneity is more lauded than individuality.

After World War II, Harajuku was a devastated area. During the American occupation it housed many soldiers and their families in a quarter called Washington Heights, which quickly became a point of curiosity for Japanese people. During the 1964 Tokyo Olympics, which showcased Japan's 'miraculous' post-war recovery, Washington Heights became an Olympic village. It became apparent to the rest of the world that Tokyo was becoming increasingly affluent, consumer-orientated and cosmopolitan.

As the economy started to grow, youth culture came to the fore. Harajuku became a magnet for fashion-conscious kids known as the Harajuku *zoku*. In 1977, the *hokoten* (pedestrian paradise), an area closed off to cars, was established. It gradually became a haven for a range of subcultures, from rockabillies to skaters, and psy-trancers even held many Sunday raves in Yoyogi Park. However, in 1996, *hokoten* came to a halt when the police made a mass arrest, deporting foreigners who were suspected of peddling drugs. It was closed, forever changing the hedonistic, free atmosphere of the area. (Today, one of the remnants of the *hotoken* are the cosplayers and rockabilly dancers that gather each week at Jingu Bridge; while the cosplayers are often dismissed as simply copying their favourite anime and manga characters, quite often their ensembles are handmade and hence show a creative spirit.)

When Japan gained renown in the 1980s and 1990s for its haute couture luminaries such as Issey Miyake, Yohji Yamamoto, Comme des Garçons' Rei Kawakubo, Kenzo and Hanae Mori, street fashionistas became equally celebrated. Publications such as *FRUiTS*, *Gothic & Lolita Bible* and *KERA* sprang up. These showcased the neighbourhood, supported burgeoning designers and legitimized street style. This has developed to the point that the Japanese Ministry of Foreign Affairs has appointed Lolita models 'kawaii ambassadors'.

The rapid influx of large 'fast fashion' shops in Harajuku has changed the area dramatically, as smaller independent boutiques struggle to stay open. However, as *FRUiTS* editor Shoichi Aoki says, this might simply be an opportunity for young people to experiment with fashion on a budget. There is still a strong focus on the way clothing is remixed and collaged rather than on the actual separate items. Moreover, events such as the Harajuku Fashion Walk, in which fans of street fashion show their love for the neighbourhood with a monthly parade, prove that the culture is very much alive and retains the playful, rebellious, fun-loving atmosphere that makes it appreciated around the globe.

Top: Model Takako Yamamoto wearing a retro kawaii Hello Kitty *yukata*.

Bottom: The legendary Jingu Bashi bridge in Harajuku, where cosplayers congregate on Sundays.

FRUiTS

Established in 1994, *FRUiTS* is a street style magazine which uses a simple formula: head–to–toe photos of fashionable kids on Harajuku's streets. It is currently edited by its founding photographer, Shoichi Aoki, and has a massive cult following around the world. When a book was published in 2001, Tokyo's fashionistas were encouraged to wear even more outlandish outfits on visits to the neighbourhood in the hope of being photographed. *FRUiTS* continues to prove that the most creative and inspiring Japanese fashion can be seen on the streets, not the catwalk.

When did you start taking photos?
When I started the magazine *Street* in 1985, I was taking street photos in London, New York and Paris. I started shooting Harajuku with *FRUiTS*. I don't take photos anymore – I leave that to the staff – but basically it is documentary photography. I make sure there is not much of the photographer's personal expression in the images. I have three or four staff members who take photos for me; they are people that have been in the magazine and understand fashion.

What is the difference between your photography for *Street* and for *FRUiTS*?
With *Street* I was just taking photos (like journalism) whereas with *FRUiTS* I ask permission, and the subjects are aware they are being shot, so the style is more like portraiture. Personally I like the *Street* style, but in Japan, shooting like that can be a problem.

What is the appeal of Harajuku?
Harajuku has fashion that only exists here, and it was the first place in Japan that had its own original fashion. The young people, instead of being swayed by what was 'in', would create their own unique style. The *hokoten* [pedestrian paradise] was hugely influential and, historically, Harajuku was a place where new things were born.

Where did the concept behind *FRUiTS* come from?
I was taking street fashion snaps overseas for a long time, and during that time, there wasn't really any creative street fashion in Japan. Then there was the design boom, which was driven by creative top designers. However, with *FRUiTS* it was the people themselves who were creative – it was that era I wanted to document.

There are now a lot of brands that create Harajuku–style items, but when you started the magazine, did people make their clothes themselves?
There were brands then, too, and a lot of people used second-hand clothing and remade items.

Where did the title *FRUiTS* come from?
It is colourful, fresh and modern.

Were you ever interested in cosplayers?
Cosplay culture came after that, and I think it is a different thing. I don't think it is fashion; it is emulating a style that already exists in anime.

What has been the biggest change in Harajuku?
I think the biggest thing is the *hokoten* disappearing.

What do you think about the emergence of 'fast fashion' chain stores?
I think it will change Harajuku fashion culture even more. The people that appear in *FRUiTS* like Forever 21 and Topshop too. But the fashion consumers in Shibuya who shop there wear the items completely differently to how Harajuku kids do.

Also, small shops are finding it harder to establish themselves and that is a really big change. There is a generation of kids that will grow up with totally different

Shoichi Aoki in the Harajuku *FRUiTS* office.

116

FRUiTS

500 yen

2

Interview

原宿
フリースタイル！

Cover of the
very first issue of
FRUiTS magazine,
photographed by
Shoichi Aoki.

fashion around them. Quite a few smaller shops are disappearing. However, with only a small amount of money they can coordinate from head to toe, and attempt trial-and-error ensembles, which is a big opportunity. I think that is the good aspect of 'fast fashion'.

When new fashions emerge, do they come from street-level up?

A few *FRUiTS* kids would start something and it would spread, like DeCoRa, in which jerseys were paired with a load of accessories. That was started by two girls who were really charismatic. Gothic Lolita, however, is a bit different. It's not something that came from the streets; magazines and brands created it.

Who appears in *FRUiTS* the most, and what happens to them?

There is always a person that stands out and these change cyclically. These people would flourish and then disappear within a few months, perhaps if they started work or weren't based in Harajuku anymore. Now, the cycle is slower and the same kids seem to stay here.

Why is *FRUiTS* successful?

I think its success came from the power of the fashion, the creativeness and the kids' talents. Also, we were the first to do it.

What kind of fashion do you personally like?

If it is complete fashion ensembles, I like all kinds. I don't care about the genre. In terms of *FRUiTS*, it is an original Japanese aesthetic, so I respect the kids of Harajuku.

Do you think handmade culture is disappearing?

I think they only made their own clothes at the beginning. Harajuku fashion is much more cultivated now, and to make handmade clothing at that level is basically really difficult.

FRUiTS has become mini-sized.

Meijidori

Single Speed
(Ino ら 3F)

←Body Wild

Candy
Showtime

Extension
Hair Salon
Sugar

TO
Shibuya

Takoyaki
Stand

Stories

Kiddy
Land

MAP 2

Harajuku
By
Useless
Ai

Meijidori

NADIA

6% Dokidoki

神宮前交番
Jingūmae
Police Station

Candy Strippers

Pariero Mart

Hangry & Angry

MILKFED

West Wing

Main Building

Dojun Wing

Bathing Ape

表参道 ヒルズ
← Omotesandō
Hills

同潤館
← Old Dōjunkai
Apartment Bldg.

Harajuku

Kumamiki runs a small brand called Party Baby, which is something of a pastel, fairy dust–encrusted art project, and also organizes the Harajuku Fashion Walk, in which colourfully dressed kids get together and make the neighbourhood an outdoor catwalk. She is one of the many adorable beings who feel an affinity with Harajuku culture and she drips with utter sweetness, both in her fashion sense and her personality.

Designer and Harajuku icon Kumamiki organizes a monthly gathering called Harajuku Fashion Walk for lovers of kawaii fashion. They parade around celebrating their love of the area and turn the streets into an open-air catwalk.

Fashion

What is Harajuku Fashion Walk?

Everyone gets together on the last Sunday of every month. I have been doing it for nearly two years. There are people who are loud in their appearance and some that are simple. It isn't so much about trends as having a sense of who you are.

How about your brand Party Baby?

I thought that becoming an adult was boring; I wanted to be an adult with the innocent, sparkly feeling of being a child. I put that feeling into my clothing designs, which are drawings from my childhood memories. I collect childrens' drawings and eventually want to incorporate these into my designs.

What is the appeal of being childlike?

Quite simply, I like it! The other day, I was wondering what I should draw, and I drew a square that started to sing. When you grow up, this kind of sensibility disappears, but I want to keep these innocent feelings eternally.

When did you first start coming to Harajuku?

When I was 17 or 18. I am originally from Tokyo so it just seemed like a fashionable area. Recently, Harajuku has started to get a lot of 'fast fashion' shops, whereas in the back streets there are a bunch of vacant shops. Independent boutiques became bankrupt and it became difficult to open new shops in the district. The superficial elements of Harajuku became really hyped up, but the real fashion people decreased as the [mainstream] trendy elements got pushed to the fore.

Despite all this, my friends and I are carrying on just as we always have. There is always this lingering voice saying that Harajuku is over, and the media loves to reiterate it. However, at the end of the day, we are still really enjoying the fashion! We want to express the power of the people that are around now, so that is why I organize things like Fashion Walk and an event called POP n CUTE [see POP n CUTE]. We can generate a youth culture based on fashion, music and art.

What is special about Harajuku?

Harajuku is a place with a lot of things chaotically mixed together where it is easy to express yourself. I am always dressed like this, and ride my bike from home looking like this. People from the suburbs really feel like they can't dress like this at home, so they get changed in Harajuku. People like us can get together, and if we connect, we can make a new culture.

What inspires you?

I go to the park and watch kids playing, and the communication between children and their mothers is really warm. I really like that atmosphere.

Walk

POP
n
CUTE

POP n CUTE is a party run by Kumamiki that is held at live music venues at irregular intervals. Though music is rarely cited as an important aspect of Harajuku culture, fashion lovers that are also in bands perform at this event, and most of the familiar faces on the streets of Harajuku make an appearance there.

Cosplay

From the 1980s to the early 2000s, Harajuku was the centre of cosplay culture. High school kids would usually come from other suburbs, get changed into their costumes – which they had often made themselves – in the toilets and stand around Jingu-bashi waiting to have their photos taken by amateur photographers. Although this culture has largely moved to Akihabara and manga conventions such as Comiket, even today, on Sundays, you will find a few cosplay kids in Harajuku dressed up as their favourite manga or anime characters.

Street

Snaps

Takuya Angel

Takuya Angel is a distinctive label founded in the late 1990s. It is the premier outfitter of the industrial scene; the clothes are candy–coloured, techno–meets–traditional Japanese clubwear. Designer Takuya Sawada favours elements of classic clothing such as kimonos, *haori* and *hakama*, but the aesthetic is positively futuristic. Each ensemble borders on being a sci–fi–esque art installation.

Takuya Angel clothing is often worn as top-to-bottom ensembles. While the pieces are candy coloured, they often draw inspiration from kimono designs.

Osaka is really over the top in terms of fashion. Are you influenced by Osaka culture?

Yes. Really outlandish fashion would become popular in Osaka, and then Tokyo people would start wearing it too. It's basically similar, but often trends are started in Osaka and then go to Tokyo. Gothic events started in Osaka, actually.

How did you start designing clothing?

Initially I had a silk kimono shop and they weren't selling well, so I thought I would remake them. I made a skirt, and the shape of the skirt was Victorian, with a big bottom and a bustle that could be tightened. It was a real hit. Eventually I got a customer who wanted a top, and this led to my making t-shirts and accessories. I started in Osaka, but then Tokyo people started to buy my products, as well as shops like Marui, and I got picked up by media outlets like newspapers, TV and magazines.

Why weren't the kimonos selling?

There is an unspoken rule that if it isn't a special day like a wedding or New Year's Day, people won't wear them. But nowadays lots of people wear *yukata* [summer cotton kimonos] in summer, so this is changing [see *Hanabi*].

What do you like about kimonos?

The shape of all Japanese kimonos is the same, but the textiles are always different. There are so many that you can't find two that are identical. The colours and patterns are exciting and the older the kimono, the more beautiful it is.

When did you arrive in Harajuku?

2001. There are a lot of other fashionable towns, but Harajuku is the only place where you can get really dressed up and walk around casually. It has a different atmosphere to Shibuya or Shinjuku in that respect. At the time, there were a lot of DeCoRa people. Cyber had mostly finished and the people that were left were the top people like DJ Sisen, the people that stood out. While I was there, the other big waves were h.NAOTO, that black style, sweet Lolita and gothic Lolita [see Gothic and Lolita Models]. The *hokoten* [pedestrian paradise] was still around, and there were so many people dressed in over-the-top ways.

How do new subcultures come about?

The interesting, stand-out kids wear amazing things and others are influenced by them. Also, magazines like *FRUiTS* [see *FRUiTS*] and *KERA* are very influential.

Are the scenes connected?

There aren't that many connections across scenes, but we get inspiration and stimulation from each other via the work, even if we haven't met. However, there is no designer community. If there had been, we could have cooperated and done events together and we could have had a stronger community, but there was no one to connect the dots.

What aspects of Japanese culture are you influenced by?

I like kimono fabric patterns, and I research historical books and books on armour from the Sengoku era [1467–1573] as well as the Kofun era [250–538], when *haniwa* dolls had clothing like trousers, leg warmers and gauntlets. I feel it's my role to research and choose things from each Japanese era and introduce them overseas.

What is the importance of fashion?

You can express who you are, what you are into and what kind of music you like through your accessories or bags. People think the heart and the exterior are different but I think they are the same. I think one's interior is often revealed through fashion: people who are polished on the outside are often refined on the inside as well.

6%DOKIDOKI

Yuka and Vani are Harajuku boutique 6%DOKIDOKI's shop girls, models and spokespeople. They tour around the world promoting this iconic institution, which opened in the mid–1990s. A lot of Tokyo boutiques, particularly those in Harajuku, rely on the charismatic presence of shop girls. Many of these girls model for the shops at shows and in catalogues, and some end up designing limited edition pieces for the label. A few even become bona fide celebrities.

Shop girl Yuka.

How did you get chosen to be a 6%DOKIDOKI girl?

Y: I was a model for a fashion/theatrical show, and then after that I became a shop girl.

V: I was a customer at 6%DOKIDOKI for a long time and I thought it would be great if I could contribute to their world, and so I auditioned. There was a 30-minute segment on *Tokyo Kawaii TV* and the whole show was the 6%DOKIDOKI audition! We were selected and had interviews, but on top of that there was a rhythm test, because in fashion shows you sometimes have to dance a little. There are also a lot of photo shoots, so we needed to do a test shoot. The pass rate is only 1 in 200 applicants!

What is the concept?

Y: Sensational kawaii. We have things that are way too cute that you can't find anywhere else.

When people overseas use the term 'kawaii', are they using it in the same way as the Japanese?

Y: I think people overseas see kawaii culture as something more aggressive and punk, in terms of visuals and philosophy. For example, at our shows, people with coloured hair and a lot of tattoos will turn up, who are more related to punk culture.

V: I think it is closer to 'cool'. In Japan we use the word 'kawaii' for things that are small and fancy.

What inspires your fashion?

V: In terms of colour usage, overseas sweets! Inspiration doesn't necessarily have to come from art: it can be from colourful animals like frogs and snakes. I think the colours that can be found in nature are really fantastic.

Why is fashion so important to you?

Y: There are many forms of self-expression, but fashion is easily communicated: you can get your message across at the first glance.

V: I think it also expresses your ways of thinking and living. I would like to convey the 6%DOKIDOKI concept through my way of living.

Shop girls Vani
and Yuka pose
in the Harajuku
6%DOKIDOKI
store. They have
become Harajuku
icons, and tour the
world promoting
the brand's ethos.

Vani.

What makes Harajuku such a special place?

Y: There is a sense of freedom in the fashion that you don't find in other towns.

V: It isn't just wearing what you are expected to, or are given. It is more like, how do you construct and express yourself? I think Harajuku is the only place where you can freely enjoy fashion in this way.

What is the appeal of kawaii?

Y: In the 1960s in America it was the hippies, in the 1970s it was punks in London and following from that, it is Tokyo's kawaii.

Conomi

Japanese schoolgirls are a national icon and are ubiquitous in popular culture around the world. The symbolic power of the schoolgirl is portrayed in films like *Battle Royale*, pop band AKB48's stage outfits, and manga such as *Sailor Moon* and *InuYasha*.

Much of their mystique comes from their stereotypically nonchalant attitude and carefree innocence. However, they have an awareness of their immense brand—like image, and are the instigators of many of the trends that sweep Japan. Their uniforms, arranged with meticulous care, range from the oddly sexy sailor *fuku* to uber—preppy checked outfits. Conomi is a label based in Harajuku that believes uniforms are more than a school regulation: they are a fashion symbol.

Toyoko Yokoyama, *Vice President, Conomi*

What is the concept of the shop?
You can freely choose a uniform, and they are uniforms that you can love. We have uniforms for girls, guys and kids. When you go to school every day it isn't just for studying: there are school clubs and romances. It is also really fun, and we make uniforms that fit this lifestyle. We want to make uniforms that show the feminine, cute and pretty aspects of schoolgirls.

Who buys your school uniforms?
Almost 100% of our Japanese clientele wear our items to school. There aren't many cosplayers wearing our items. If the school they go to has a uniform already, they wear ours on the weekend, or they attend a school that allows you to choose your own bag or vest. Either way, they are all students.

You don't sell official school uniforms?
No. We have uniforms you can wear freely and coordinate as you wish. There are no other shops that sell uniforms as fashion, where people buy them for fun.

How did you get started?
We originally had a shop in Niigata, which is really in the countryside. When I was a student, the school I went to had a really frumpy uniform and I hated it. In order to make it cuter we would try to arrange it differently, which made the teachers angry. We really wanted the uniform to be changed, but that never happened and after I graduated, the school uniform disappeared.

I was working at a small provincial shop that sold old ladies' and kids' clothing and students would come in and ask for uniforms, but ones that were cute. We got one made on special order and it was really popular, to the point that we couldn't keep doing it by special order anymore.

Is it true that girls choose their high school according to how cute the uniform is?
Yes, it's true! It's actually very important. If the uniform is cute at a school, students really want to go there.

What are the characteristics of school uniform design?
With uniforms, the items are set: there is a blazer, a shirt, a cardigan and a checked skirt, a ribbon, a necktie bag and socks. If you change these things, it is not a uniform anymore. The fun of it is in how you express your individuality. We make uniforms that are essentially for school as opposed to play, so they're not too over-the-top and we won't get in trouble with parents or teachers. Keeping this in mind, we make items with girly silhouettes and pay attention to the colours and the checked patterns.

Do you mostly make preppy ensembles or sailor outfits?
Mostly preppy. It's rare for us to make sailor outfits. Sailor outfits come with the idea that the dullest are the best dressed, so they are hard to style. If the uniform is blazer-style, you can style the cardigan, vest and shirt in various ways. The image of sailor outfits is more that of innocence.

A Conomi shop
girl models the
classic sailor-style
school outfit.

On weekends, fashionistas don items from the Conomi range as casual wear, such as this pink cardigan.

The Conomi store
in Harajuku.

What are these uniforms based on?

We avoid looking at other things as much as possible. Sailor uniforms came from the UK but evolved separately when they came into Japan. We want to transmit new ideas from our brand rather than looking at the uniforms of other countries. We get inspiration from places like cake shops or supermarkets: we look at fruit!

Why do you think Japanese schoolgirls are so iconic?

They are good at expressing themselves!

Why do students who go to a school without a uniform want to wear one?

Even if a girl is really cute or pretty, when she stops going to school, wearing a uniform is just cosplay. Only schoolgirls can wear and express a uniform authentically.

When did uniforms become cool?

In the past, it might have seemed like their wearers were being tied to the school and their rules, but now wearing one is seen as a sign of freedom. Schools with uniforms are selective, so their students are girls from good families or intelligent girls. There is an element of cachet – like, if you go to this fabulous school, you can be stylish and fashionable.

Who are your biggest overseas clients?

Americans and then Europeans. The way the items are viewed in Asia and Europe is a bit different. European clients are influenced by manga and anime; they like the idea of cosplay. But our Asian clients see uniforms as a kind of fashion.

Where does Japanese cute culture come from?

I think Japanese girls suit being cute rather than really sexy. When a really sexy girl wears a uniform, she is not 120% cute. When a really normal girl wears a uniform regularly and looks really cute – that is what uniform fashion is about.

Nails

Chieco Nakayama is a nail artist who makes adorable designs favoured by kawaii fashion models, and her work is often featured in kawaii magazines.

Gothic and

American-Taiwanese model Rin Rin and veteran gothic Lolita model Chikage are two of the well-known faces who regularly appear in the catalogues of prominent Lolita labels such as Baby, the Stars Shine Bright and Angelic Pretty, as well as in the *Gothic & Lolita Bible*.

Rin Rin and Chikage, *Models*

Rin Rin

How did you begin modelling?
I became a freelance model after being approached by a couple of photographers when I was in the US. I had never really considered modelling before that.

Were you already familiar with the Japanese gothic and Lolita culture when you were approached by brands like Angelic Pretty?
When Angelic Pretty came to Los Angeles to put on a fashion show I modelled in that, and bought some of their clothes. I had also seen the *Gothic & Lolita Bible* that my friends bought as a souvenir, and I flipped through it and I was like, 'This is ridiculous!' When I first saw it, I thought the punk and darker things were really cool and I wanted to wear them. I never thought that the pink or frilly stuff would look good on me.

Rin Rin is an American-Taiwanese model who made her name in the industry by first appearing in the street snaps of popular Harajuku fashion magazines, such as *Gothic & Lolita Bible*.

Lolita Models

What are the characteristics of their clothes?

Angelic Pretty is very sweet, and it is one of the most famous brands. It is a rival of Baby, the Stars Shine Bright, but that is more classic, whereas Angelic Pretty is very candy and sweet pop.

What kinds of people are attracted to Lolita fashion?

They are very shy. When I talk to the guests at tea parties, a lot of people say that they don't have self-confidence, but when they wear Lolita clothing they feel that they can become a different person. They can have an alternate personality and can express how they feel more freely in these clothes than they do in their normal lives.

What kind of models do the magazines want?

I had a meeting with an editor and he said, 'You have to work on your uniqueness.' That is really important. They need someone who is unique and can mature as time goes on; someone who can stay relevant, bring new ideas and set trends.

Chikage is a veteran gothic Lolita model with over 10 years' experience.

Are the models into the lifestyle as well?
Usually, but there are some magazines that use agency girls. Most are scouted and approached while walking around the streets of Harajuku and they get introduced to the lifestyle from there.

Is the Lolita lifestyle a celebration of femininity?
Yes, definitely. I feel that it is really great to be a girl. You can dress up and become a doll, basically – something ideal.

Chikage

When you started, was the darker, classic goth style the most popular?
It was a long time ago and it's not like now, with all these colourful people. It was just black and white and there was definitely no pink! I started in the early 2000s when I went to a gothic Lolita event and told a photographer that I wanted to model. I have modelled for almost all the Lolita brands, and also as a maid [see Maid Cafés]. I'm not a maid, but I model for their brands.

What exactly happens at a tea party?

They have a fashion show and the designer gives a talk, and everyone takes photos. They are usually held at the [religious-themed] Christon Café or at a hotel. A lot of the guests also frequent cute cafés on their own. The tea parties are usually really quiet as the culture has a lot of shy people. Once I sang, because I was in a hard rock band. During the performance, everyone was dead quiet. I was like, 'I really shouldn't have done that!'

What inspires you?

Tim Burton films, and I really like B-movies and horror movies. I like 1980s movies and *A Clockwork Orange*, too. I also enjoy manga like *Magic Knight Rayearth* and *Sailor Moon*.

Why do you like this style?

I think it is the influence of my mum. She was really into frilly things, and I was made to wear them. At the time I was teased, but as I got older I came to like them.

Hangry & Angry

Gashicon is the designer and illustrator of the label Hangry & Angry, a division of designer h.NAOTO's fashion empire. Hangry and Angry are two characters that usually appear in plush animal form, and then became a line of clothing – perhaps the only fashion line based on characters that have their own narrative. The clothing is often blood–splattered and torn, with a pop yet punky feel and unusual cuts.

What kind of message do you want to transmit via your clothing?

It is an individualistic and special clothing brand and embraces a look that isn't common. For example, the clothing has ears and is torn.

I don't look all that over-the-top now. But when I was a teenager I wasn't very good at self-expression – so I would decorate my exterior. The people who wear my apparel are around that age, and want to express themselves through fashion, so I want the clothing to serve that purpose.

When you were in your teens, were there many brands like this?

When I entered this company I was 19 and I liked h.NAOTO and was wearing it a lot. Now that I have my own brand, I have a lot of opportunities to talk to people that have the same feelings I had during that time. A lot of them want to make clothing too.

Are magazines important in Harajuku culture?

Yes. I read magazines and became familiar with all the brands from Harajuku. I did a lot of mail ordering! The Internet is important as well, of course, but to have all that information stuffed into one magazine is a dream. With the Internet, if you search you can find anything, but you are just looking and looking and you don't know where you are. Magazines make an entire Harajuku world, and you can really tell what kind of town Harajuku is by looking at them.

What is the appeal of manga?

It is real, but not real. You can go into that world and get absorbed to the degree that you can't even hear what is going on around you.

Why did you start making manga yourself?

I started with Hangry & Angry, although I am not actually a character designer per se. There weren't any brands based on characters, so we thought it would be an interesting idea, and the manga came afterwards. When I initially entered this company I was a graphic designer,

Designer Gashicon with her horror-inspired plush toys at the h.NAOTO headquarters in Harajuku.

making textiles with realistic ghost illustrations or punk/goth designs. There was a proposal that we should start making characters and, at the time, there was a strong punk and gothic Lolita image attached to the brand. We thought it would be interesting to make a character like that.

What kinds of horror films are you into?

I prefer overseas horror films rather than Japanese ones because I don't like *yurei* [Japanese spirits]. I'm fine with splatter zombie films, but I really can't stand *yurei*. They are completely frightening because I almost believe in them.

Would you agree that overseas horror films are quite funny?

Japanese ones are genuinely scary. They depict things that appear in your dreams. They are interesting for that reason, but I begin to wonder what I would do if they were real!

Splatter films have an element of humour, because they are too over-the-top to be realistic. I also like the visuals, such as the special effects make-up, and the overall vibe.

A staff member at the Hangry & Angry Harajuku store models a H&A cat-eared hoodie, part of the 2012 Spring/Summer line.

I watch a lot of movies in general, though, one a day. I will watch anything that interests me, especially films that I can connect to Hangry & Angry. In terms of directors, I like Shunji Iwai and David Fincher. I love *Se7en* and have seen it dozens of times.

Is it normal for young girls to be into horror?
Not really, but if you go to department stores in Japan, there is always a horror manga corner next to the *shojo* manga in the book section. I find the style visually interesting, more so than the things that are just cute.

Hanabi

Hanabi (fireworks) are a Japanese tradition, and the highlight of the summer season. The most anticipated is the Sumidagawa Fireworks Festival, which takes place alongside the river at Asakusa.

While it is rare to see kimonos in everyday life in Japan, since they are usually only worn on special occasions, several kawaii designers put out *yukatas* (light cotton kimonos) every summer. *Hanabi* festivals are the best place to see girls dressed to the nines in their favourite *yukatas*. No two patterns are the same and the designs are increasingly modern, featuring motifs like apples and bears, and adorned with lace and glitter.

Comiket

Comiket is the world's largest manga fair for self—published work, otherwise known as *doujinshi*. *Doujinshi* are comics created by amateur fans of manga and distributed off the commercial circuit. The first Comiket took place in 1975 and had 600 guests, but it has since swelled to over half a million people. The fair takes place over three days at Tokyo Big Sight, a futuristic—looking two—acre convention space.

A lot of *doujinshi* are based on parodies of pre—existing manga titles, with the characters engaging in new (sometimes sexual) narratives. Though Comiket is more in the *otaku* (geek) culture than the Harajuku kawaii culture, it is the main event for cosplayers, around 15,000 of whom attend each year. The outside area is packed with people decked out in every costume from simple *Dragon Ball* outfits, to robots in the shape of vending machines, to characters from *Neon Genesis Evangelion*.

cute

crafts

Traditional Japanese crafts are lauded for their sophisticated and refined use of colour, sense of minimalism and emphasis on the natural qualities of the raw materials. In each item is evidence of incredible workmanship, a meticulous eye for detail and a slight warmth and imperfection that can't be achieved with mass production.

Japan historically has a rich crafting culture and, even today, the quantity and quality of handcrafted items in Japan is simply breathtaking. Many of these, such as lacquer, ceramics and woodwork, were traditionally made within local industries supported by feudal lords. This system continues today under the umbrella of the Ministry of Economy, Trade and Industry.

Although contemporary crafts make limited use of mechanization, there have been technological developments in techniques and materials, such as high-grade metals for blades and greater variety in papers and paints. Many modern crafted items retain elements of tradition in their composition, motifs, colour usage or form while adding an artist's unique sensibilities. Hence items that might seem inaccessible or staid to younger people can be renewed for a contemporary audience.

Aside from traditional crafts, in kawaii culture, much like the crafty bloggers abroad, there are numerous communities on- and offline based on niche interests such as kawaii candle making, soap making, fake sweets, felt toys, knitted items, crocheting and making clothes for dogs and dolls. At shows it is evident that the love of cute crafts is not restricted to young girls – there are just as many older women who are enthusiasts. There are at least 70 craft-related monthly magazines in Japan, such as the *Kawaii Tezukuri* series and the mind-boggling *Deco Design Collection*, a magazine for bedazzled items.

Design Festa is the best place in Japan to check out the work of both amateur and professional crafters. The relatively inexpensive booths allow many young artists to display their wares, and the event celebrates DIY creative spirit.

Otome Kokeshi

Yumiko Yamamoto handmakes minuscule, glammed-up dolls called RIBBON and bears that fit into matchboxes. Delicately dressed in adorable fashions, they are made with such loving care that each one is entirely unique. She runs a shop full of cute items from Europe called Papenhaus with graphic designer Shigetomo Yamamoto (see MonsterGirls).

When did you start developing an interest in dolls?
In the early 2000s with [well-known doll] Blythe. My friend made a replica with a big head. At first I thought it looked really grotesque, but gradually I came to appreciate her cuteness. From there, even though I was an adult, I got into dolls.

Who is RIBBON?
I don't have a set narrative for her, so the customer can decide what her background is without me creating one for them. We don't even make it clear if it is a girl or a guy, so the customer can interpret RIBBON how they want.

What are you inspired by?
Our shop has a lot of things from Western Europe from the 2000s, like children's books. I like the colours in them and the dolls from that region, as a lot have quite immature faces.

What makes something cute?
In my case, I simply try to make it adorable. I don't like putting my own personality into the dolls too much. I also make music; I put my own private feelings into that instead, and use it as a means of expression.

RIBBON

von Marie Niedner

handmade sweets

*Every day throughout this season,
I'm going to send you a smile.*

What kind of music did you make?

Hardcore techno! I'm not doing it anymore, though. But in the late 1990s I was releasing records under the same name in Germany and France and also DJing. I was really intense then, although I liked cute things too. When people listened to my music, they assumed that a guy with a beard had made it. My desire to make these adorable girly things might be a reaction to that.

What can you say about Japanese kawaii culture?

It is normal to think a dog or cat is cute, but a Japanese person will call a mandarin kawaii. They have emotions about a mandarin. And this has been around for a long time!

Design

Design Festa is a biannual art event that plays host to 10,000 visual and performance artists, live painting installations, fashion shows and musicians. It is Asia's largest art event, and each stand only sells original items. While there is a wide range in quality, it is a great place for crafters, and the items on offer are saturated with kawaii sweetness.

Festa

Booths at Design Festa are some of the best places to see kawaii crafts, such as these hunting trophies by Ijiwaru.

Kokeshi in Naruko Onsen

Kokeshi are traditional wooden dolls that originated in the Tohoku region of northern Japan in the early 19th century. Although they can be found everywhere, the traditional forms are still only made in this region. After the wood is cured, it is spun on a lathe, polished and painted. The dolls are feminine and have gentle facial expressions, and are thought to be healing and calming. Each one is handmade and the craft takes a decade to perfect.

Naruko Onsen in Tohoku is kokeshi heaven, boasting a museum with over 4,000 kokeshi on display which holds charity auctions. There is an annual kokeshi festival with floats and a competition, and everywhere you look there are kokeshi shops and artisans. Even the taxis, street signs, fire engines, manhole covers and telephone boxes have kokeshi on them.

Yasuo Okazaki, *Kokeshi Artisan*

Yasuo Okazaki is a kokeshi maker in Naruko Onsen. The kokeshi is made by spinning wood on a lathe, which is then cut, polished and painted.

What is the history of kokeshi?

They were originally made for children, for everyday use as a toy. There are 11 different types going from Aomori to Fukushima and they all have different names, but in 1940, everyone got together and decided collectively to call them kokeshi so that they would be easier to sell.

What are the characteristics of Tohoku kokeshi?

Tohoku mostly produces traditional kokeshi. There are artistic styles of kokeshi that are really expensive and are more like sculptures, and others that are just souvenirs, which are mass-produced and cheap.

What are the characteristics of traditional kokeshi?

Each type has different patterns and they don't copy each other's style. I use the same patterns and styles as my grandparents and parents. In Naruko there are four different styles, and we can't break this tradition.

Yasuo Okazaki's kokeshi are exemplary of the Naruko style, which features simple, classic designs and facial features that he describes as 'healing'.

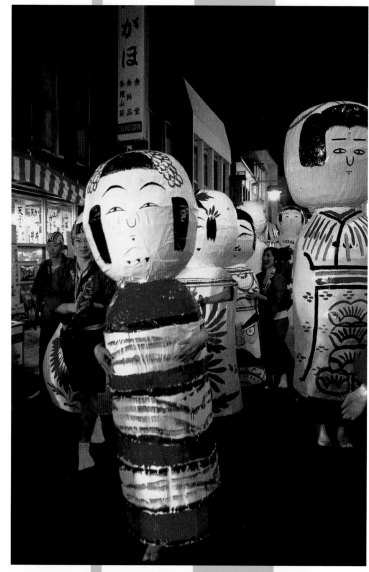

Kokeshi are even celebrated with a festival, where old kokeshi are blessed and then burnt at a shrine; there is a parade afterwards.

The women of Naruko Onsen perform a dance at the Kokeshi Festival wearing kokeshi kimonos.

Is the skill usually passed through the family?

Yes, or you can train somewhere and become a *deshi* [student]. In my case, I am third-generation, and now I am teaching my son. Before that, my father or grandfather painted them and I just chiselled and polished the wood.

What kind of wood do you use?

In Naruko we use dogwood. It is easy to use, the hardness is perfect and the wood is white.

How long does it take to make one?

I make 15 a day. I am a craftsman so I need to make that many to survive, because we aren't artists. If we were selling them for $100 it would be OK, but they are kids' toys, so we shouldn't charge too much for them.

Kokeshi motifs on the side of a fire engine.

Naruko Onsen is home to several kokeshi artisans. The entire town is dotted with kokeshi motifs, such as these handrails.

How has the technology changed?

Now the lathe is run by a motor, whereas previously it was powered by foot pedal. Other than that, it is the same.

How about the paint?

It is all *sumi* [ink made from charcoal]. The red dye is the same as kimono dye. Nowadays red food colouring is common, but traditionally Yamagata Prefecture's safflower dye was used for lipstick and things like that. If we use dye, the colour is beautiful and 50 years from now, it fades – but that is a sign of good quality. Unlike acrylic paint, which doesn't change in colour at all, with dye, as the wood ages and gets brown and the paint of the eyes fades, it gets more beautiful.

What is the best thing about kokeshi?

When you get home from work, they give you a kind and soft feeling. Kokeshi are the soul of Japan.

What happens at the kokeshi festival?

There is a competition and everyone tries their hardest to win. The work is exhibited and people can buy them. On the first night, all the old kokeshi that are cracked, dirty or unwanted are collected. They are taken to the shrine and a Shinto priest does a purification blessing, and then they burn them and send them off to the next world.
The next day, the best kokeshi is donated to the shrine as an offering.

Kokeshka are hybrid kokeshi/matryoshka dolls produced by cult poet and photographer Genqui Numata. They range from flight attendant kokeshi to kokeshi with apple faces and kokeshi postmen (which are hollow and can be put in the post to send short messages), and summer kimonos feature rainbow-coloured kokeshi motifs. Numata is also hugely active in hosting charity campaigns for the Tohoku region, and is one of the biggest instigators of the recent kokeshi revival.

Kokeshka

Are there kokeshi dolls in most Japanese people's houses?
Yes. However, most houses would only have one or two. We had about 100! My father collected them and my mum was born in Russia, so there were matryoshka dolls in my home as well.

What is the concept behind kokeshka?
My father and mother are both Japanese, but my mother was born in Russia and grew up there. Matryoshka dolls give birth to a lot of children and the word means 'mother'.

In Edo-period [1603–1868] books, there are depictions of *iroko* wooden items in Hakone, which is a region in Kanagawa known for producing wooden toys and dolls. There were *iroko* dolls with the same nesting idea as matryoshka, and were the prototype for the first matryoshka when they were taken from Japan

Genqui Numata.

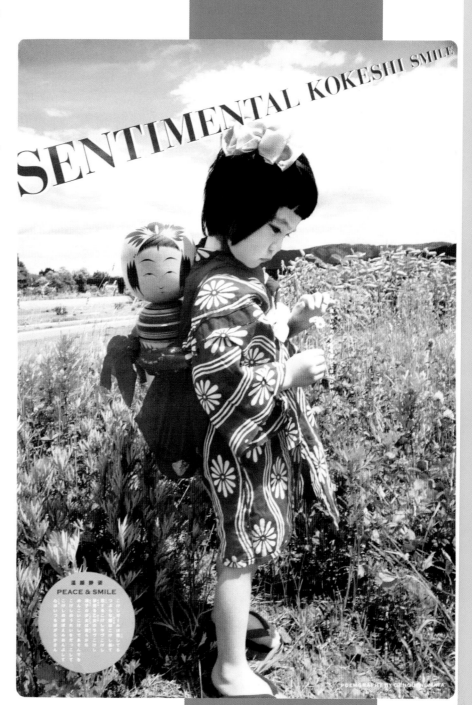

Numata is loved for his retro-chic imagery, including this shot of a village girl who carries around her beloved kokeshi. The dolls were once the standard children's toy in the Tohoku region of northern Japan.

SENTIMENTAL KOKESHI SMILE

to Russia in the 1890s. You can see the *iroko* that formed the basis of matryoshka at the toy museum in Russia. It was actually a religious talisman depicting the Seven Lucky Gods nested inside each other.

At the time, there was a lot of prejudice towards farmers among the Russian nobility. However, there were also some intelligent people who realized that agricultural workers were extremely important in producing food, and it became a kind of trend to admire farmers for a while. As such, it is thought that the doll was based on farmer girls.

Before the Soviet era, were they handmade?

Yes, and when they came to be mass-produced in factories, the quality went down – but so did the price.

Why are traditional kokeshi only found in the Tohoku region?

It's a mystery! There seem to be kokeshi in Kyushu Prefecture too, with arms and legs. For something to be considered a kokeshi, it has to be made with a lathe. There are wooden dolls all over the world, but if a lathe is used, it is called a kokeshi and the person who makes it is called a *kojin*.

A particularly interesting point about *kojin* is that they make everything on their own. Artisans are specialists that usually only make, for example, illustrations, or carve wood. However, traditionally *kojin* would get the wood from the mountains, polish it, paint it and sell it – they do everything.

PEACE & SMILE

Kokeshka
dolls are a mix
between Russian
matryoshka and
Japanese kokeshi.

Is there some kind of religious meaning behind kokeshi?
There are various theories. One suggests that they were used in memorial services for dead children. But I don't think that is true; it is something that people said afterwards as a way to sell them. Their use was celebratory, such as for birthdays and Hinamatsuri [doll festival] in March for girls; they were used as decorations.

Where do you have your goods made?
We design them, and then I either ask kokeshi craftsmen to actually make them, or else Russian producers.

How do you think kokeshi relate to contemporary kitschy kawaii things?
Kokeshi are really simple. They are just wooden poles. But, like Hello Kitty, they rely heavily on children's imaginations. When a happy kid sees them, he or she can construe them as being happy, and when the child is sad, they also look sad.

Why are you so attracted to kokeshi?

I like the simplicity of them. I am also a poet, and though Western and modern poems can be long, haiku are short. They stimulate your imagination with just a few words. I feel that it is the same concept.

How about matryoshka dolls?

A lot of skill is needed to make them fit inside each other perfectly and in Japan there are very few people that can make them anymore. They are not for children – they are for adults – so they are flirtatious and try to be appealing, whereas kokeshi are demure, like the women in each culture. They both represent attractive aspects of women.

The kokeshi displayed at the Kokeshka store. Numata's status as a cult photographer and poet and his interest in kokeshi is one of the main reasons for the spike in popularity of these traditional dolls.

Aeroflot flight attendant kokeshi dolls.

Useless

Ai, a designer and crafter born in the 1980s, is the creator of Useless, a curious green dog whose tongue always sticks out. Useless was first drawn as a doodle by her husband but, after a colour change, the character gradually acquired friends and now has an international following.

Ai is a designer and crafter with an international following. Much like crafters overseas, she participates in online communities and forums where she garners most of her fans.

Michi66

Michi66 is a designer, illustrator and crafter who makes gigantic rabbits called *katamimi*. They have become familiar sights in Japan's underground, making appearances at clubs and street culture exhibitions. They are beloved for the fact that they are handmade and slightly creepy. The simple concept of her work is, in her words, 'To cherish things. Important things are transient and fade away, so it is really vital to be able to appreciate them.'

Michi66 and her *katamimi*.

Larger

than

Most people define 'kawaii' as describing items that are pocket–sized, while giants such as Godzilla and the massive Gundam robot installations that appear periodically around Tokyo convey a sense of power and destruction. However, artists such as Yayoi Kusama, Takashi Murakami, Florentijn Hofman and Yotta Groove challenge this notion with their giant inflatable characters.

Yotta Groove's 'neo–traditional kokeshi idol' Hanako is a 12.5–metre–tall blow–up kokeshi inspired by the simple and humble traditional dolls that can be found in the six prefectures of the Tohoku region. For the artist, kokeshi encapsulate the Japanese sense of aesthetics. The designs on Hanako are an amalgam of each region's traditional patterns; the doll sings, talks and stands in a footbath. Hanako initially appeared in the city of Osaka and then moved to Roppongi Hills, one of Tokyo's most exclusive shopping malls, where people flocked to see her and were in awe of her towering size.

Perhaps it is as Dutch artist Florentijn Hofman, who made a huge inflatable duck that swam in the canals of Osaka, says: 'The work doesn't change in size, but the world does. If you make such a huge version it even makes us reflect on the city and maybe the world at large.' Osaka–ites were so in love with Hofman's duck that there was a collective state of panic when it was announced that it was in hospital (due to a rupture), and joy when it finally returned. The duck comes back to Osaka every year, and is a beloved icon of autumn.

Florentijn Hofman, *Rubber Duck, Osaka Canvas,* 2009, inflatable, pontoon, generator.

Life

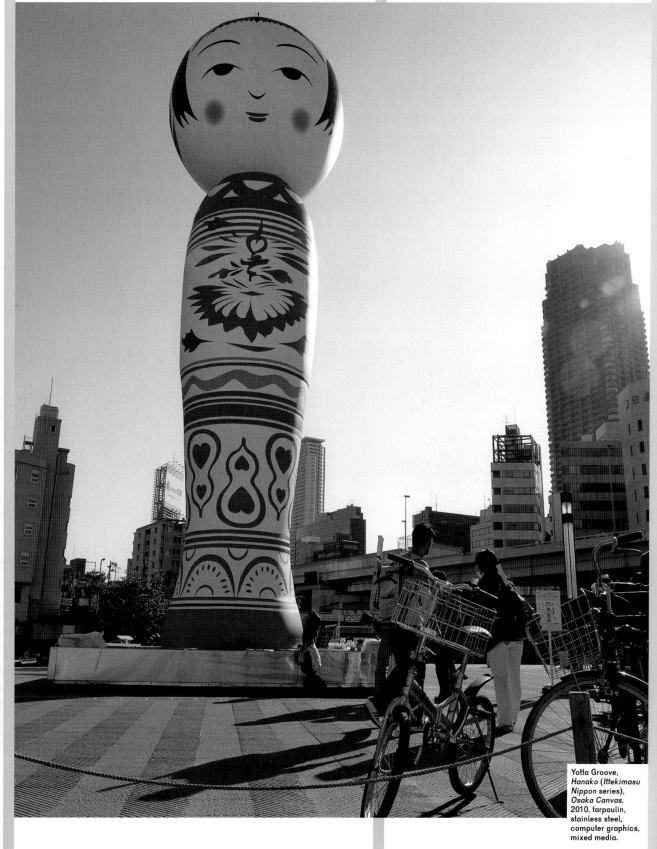

Yotta Groove,
Hanako (*Ittekimasu
Nippon* series),
Osaka Canvas,
2010, tarpaulin,
stainless steel,
computer graphics,
mixed media.

kawaii

visual art

Kawaii's international appeal is part of Japan's cultural capital and export economy. As such, many items are labelled 'kawaii', packaged as such and sold abroad as the latest in Tokyo pop culture cool. This also applies within the world of contemporary art, since the Japanese art market relies predominantly on exports and collectors from overseas.

Most foreign art enthusiasts know about the concept of kawaii through the efforts of art superstars Takashi Murakami and Yoshitomo Nara. Additionally, Murakami's agency Kaikai Kiki has a penchant for discovering female artists whose work fits into the kawaii idiom, such as Haruka Makita, Chinatsu Ban and Aya Takano, while the Kaikai Kiki Gallery has hosted many exhibitions by up-and-coming artists such as Chikuwaemil and John Hathway.

Meanwhile, in the US, Murakami's phenomenal popularity and clever branding has parlayed kawaii into an art movement as opposed to an adjective. It comes with the connotations of being Asian (not necessarily Japanese), round, cute, pop, colourful and character-driven and sporting a manga aesthetic. There have been several kawaii-themed art shows, and there are even management companies, like Sweet Streets, that 'represent artists who identify with kawaii', such as Chinese-American artist Luke Chueh, Chikuwaemil and Shojono Tomo.

Interestingly, Shojono Tomo has mixed emotions about being identified as a kawaii artist; with her aggressive lines and punk-like intensity, she feels an affinity to what she calls 'anti-kawaii'. Similarly, Junko Mizuno suggests cuteness without specifically trying to emulate it via her erotic, horror-infused pin-ups, simply reflecting the Japanese youth culture with which she grew up.

The gamut of artists that can be called kawaii is seemingly endless, although the interpretations of what kawaii entails are highly subjective. Kawaii art spans from the soft, ethereal works of Yosuke Ueno to the *kimo-kawaii* (creepy cute) sculptures of Yoskay Yamamoto. These artists appropriate kawaii motifs into their work, presenting them in new and often challenging ways.

Left: Junko Mizuno, *Venus Cake: Artichokes*, 2012, acrylic on canvas.

Right: Osamu Watanabe, *Sugar Horse – Chocolate*, 2011, modelling paste, resin, acrylic, clay.

John Hathway fuses scientific genius with a love of *shojo* manga to create dense, futuristic landscapes packed with incredible detail. Look closely at his chaotic urban scenes and you will see a menagerie of characters ranging from Lolita–esque girls, witches and aliens to salarymen floating around amid shops and street signs.

Artist, *otaku* and science geek John Hathway reading up on quantum physics. His art shows his love of *otaku* culture as well as scientific theory.

John

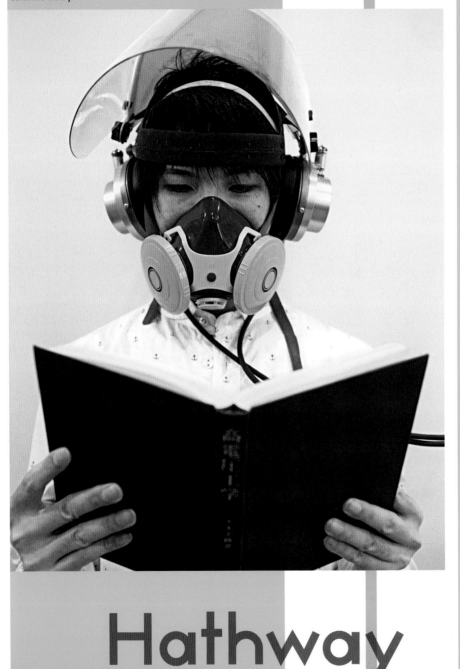

Hathway

Who is John Hathway?

The name is a mix between John Hutchison and George Hathaway, who discovered the Hutchison Effect [which says that, under certain conditions, an electromagnetic field is so strong it can cancel gravity and cause levitation]. I still don't know if the theory is true. I was in primary school and saw it on TV. Initially I was into robots, but I realized that I needed to understand physics and started experimenting, and was making a whole bunch of Tesla coils when I was in junior high school.

Wasn't your mum worried?

Yes! I was doing experiments in my bedroom, and once I burnt the *tatami* [mats], but she is really cooperative. I destroyed a lot of appliances. And I couldn't actually confirm the theory.

What was your first artwork like?

I went to a boys' middle and high school and, in order to understand girls, I would secretly buy *shojo* manga such as *RIBON*. I really liked the illustrations and the atmosphere of them. When I went to university I studied physics, but at home I was drawing girls' illustrations. Gradually I started getting work as an artist. When I stopped doing physics, those elements came flowing into my manga.

Why is kawaii so lauded in Japan?

In Japan, and maybe the whole of Asia, there are lots of girls who are cute rather than being pretty. Japanese guys realize the value of

Taito-ku Ametate Street, 2008, digital image.

this and don't only like the pretty girls. A lot of manga, fashion and other industries took this into account. From the start I only ever liked cute girls as opposed to pretty girls, but lately I have begun to see the value of both. In my recent work the girls are taller and prettier and more erotic, but I still feel a dilemma about this.

What other themes do you use in your work?

When I was looking at [publishing house] Shougakan magazines in primary school and kindergarten, a really common theme was 'the future', and what the 21st century would look like. Pictures depicted streamlined buildings with flying cars and there are still advertisements with that kind of imagery. But in the end, in Japan, the design of cities is not coordinated holistically. The shops are just run by regular people putting out signs as they like, with their own choices of colours.

Why is it acceptable to call yourself an *otaku* (geek) now?

You don't have to go to an *otaku* shop to see this culture – you can see it anywhere. I am not of that generation, so if I look at it objectively, it just looks like one of the choices a teenager can make. Also, if a cute girl or hot guy is into it, it is seen as more and more acceptable.

Who are the girls in your work?

The centrepiece is the most beautiful girl, but most *shojo* manga usually only feature pretty girls so the range of characters is

limited. If you look at the manga
Dr Slump, there is a wide variety of
characters. Similarly, in my work,
I use people of various nationalities
and different ages and even aliens;
that way the girl really shines as
there is something to compare
her to.

Can you explain your use of
perspective?
I try to put as much information as
possible into one work. A piece can
take up to six months to complete,
just like an oil painting. To put
all these various spaces into a 2D
space in an efficient way, I utilize
unrealistic perspective techniques
such as fisheye, but I need to make
sure you can read the information
on the signs.

The head to body-length ratio of
the characters at the front is high;
the faces are small. The faces are
bigger the further back you go, so
you can recognize the features.
That is one of the techniques you
see in manga.

Magic Town, 2006,
digital image.

Chikuwaemil

Chikuwaemil's work is a chaotic explosion of colour, shapes and emotions. While it is drenched with cuteness, it has a frenetic energy that makes it more engaging and multi-dimensional than art that is traditionally labelled kawaii.

Chikuwaemil.

Where does your desire to paint come from?

For a long time, I was scared to be alive. And there was a time when I was really into science fiction and horror films. From these I would get a sense of fear, and I would draw the things I found incomprehensible or agonizing.

What are you inspired by?

I am inspired by the universe at large. Aside from scary things, I also like cute things like cats, animals and flowers. But usually it is the things I see on a daily basis and the things that are inside my heart that are manifested in my paintings.

I also like techno music and the soundtracks from anime and computer games.

I enjoy American cartoons, like the ones on the Cartoon Network such as *The Powerpuff Girls* and *My Little Pony*, as their use of colour is really beautiful. Compared to Japanese manga I find them really fashionable, even the food that they eat, the way they talk and the party atmosphere.

Meal is Yummy,
2010, acrylic on
drawing paper,
mixed media.

Who are the characters in your work?

Cats, aliens, ghosts and girls in a fantasy space. The girls are kind and can do anything, even fight. They are like witches.

Are you an *otaku*?

Yes. I like *otaku* culture, the characters from anime and the products, and I have liked cosplay ever since I was in junior high school.

You are from Osaka, the mecca of over-the-top underground culture, right?

Yeah. The loudness of my work is Osaka-ish. The old ladies walking around Osaka are really gaudy. They wear gold things, dye their hair purple and wear leopard shirts with Yon-sama [a Korean soap opera star] on them. It's a confusing type of gaudiness. It's a city where people laugh a lot – they really feel that life without humour is pointless.

What do you think about when you make your art?

Ever since I was a child I have had a habit of putting my emotions into drawings. I thought I might be sick, even, but I couldn't stop. I feel that drawing has a lot of power, like wish-giving powers. If I'm in a dark mood, that will manifest itself in the work. I prefer to draw bright work all the time, because I want the people who look at it to feel good.

Girl Colored with Tears, 2010, digital image.

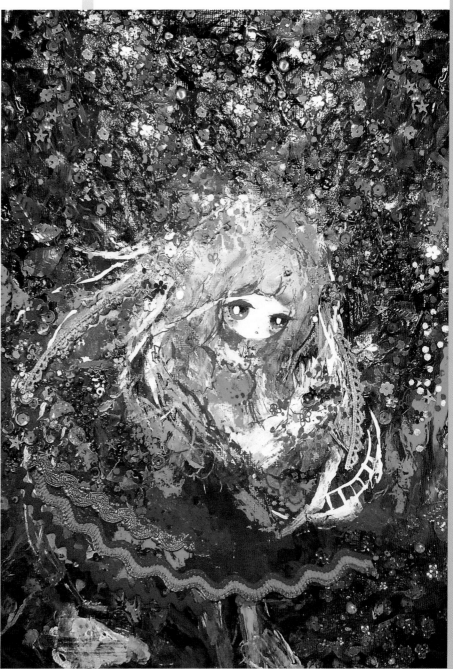

Color of Light,
2010, acrylic on
canvas, mixed
media.

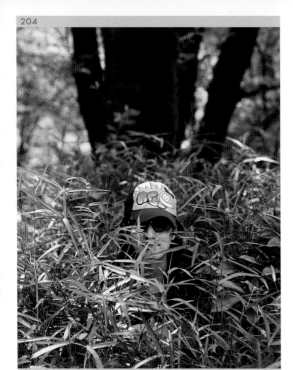

Yosuke Ueno.

Yosuke Ueno paints sweet, dreamlike scenarios featuring otherworldly characters. Aside from his main protagonist, a pixie-like girl with rainbow-coloured hair, his work portrays fantastical creatures that include elements both of nature and popular culture, such as a white elephant that dons sneakers, a skeleton that serves drinks at a tea party and swans that wear bejewelled crowns. Dense with symbolism, Ueno's paintings suggest Buddhist overtones, philosophical equations and references to classical paintings.

Yosuke

How did you start making art?

I have been drawing manga since I was a child. When I drew the sun I would add a nose and mouth. In that way, the image would get more complicated and I would try to express emotions with the characters.

When all the other children eventually stopped drawing, I continued. I think this was because my mum didn't show much affection to me, and I was really shy until I was seven years old. When I went to primary school, I couldn't make any friends. One day, a classmate complimented my manga. Because of that, I started drawing manga for my classmates and knew I wanted to be an artist when I grew up. Basically, because of drawing, I made friends and learnt how to talk.

Ueno

Girl Floweregg Like a Buddha Style, 2012, acrylic on canvas.

What are some of the messages infused in your work?

Broadly, there is the theme of positive energy. Life is difficult, but let's still live positively! It's not really a message; it's more just trying to convey an uplifting feeling.

Are you inspired by overseas comics?

I would copy and draw *Tom and Jerry*. It's so different to Japanese anime; it's like a musical. I wasn't that attracted to the storyline – there is no story – but I liked the visuals. I have a huge interest in overseas culture, such as Egyptian pyramids.

Are you influenced by Japanese culture?

I really like Japan and am heavily influenced, for example, by old *byoubu* [screen] paintings, temples, shrines and Japanese gardens. They express Zen sentiments, which I find really cool. In Western culture there are proportions that make something aesthetically pleasing, such as in a beautiful Western vase, but Japanese people will find beauty in a lumpy bowl. Famously, Queen Elizabeth went to the Buddhist temple Ryoan-ji in Kyoto, and when she saw the garden, she said that she couldn't understand the Japanese sense of aesthetics.

Are you influenced by other Buddhist elements?

The things that enable humans to express their imaginations most clearly are art and religion. In Rome, the churches are incredible; so are the people's imaginations and folktales.

There are many temples in Japan and when I was studying them I thought they were cool. Buddha lived until he was 85 years old and it feels like a really mature theology. Japanese Buddhism is really laid back. If it was strict I would get tired of it, but it's relaxed and quite forgiving.

Forestia, 2008, acrylic on canvas.

*Cloud Dragon
(Positive Energy
No. 8)*, 2012,
acrylic on canvas.

Yoskay

Yoskay Yamamoto takes icons from Japanese and American popular culture and tweaks them in a way that is funny, yet slightly creepy – what is referred to in Japan as *kimo–kawaii*. Having spent much of his life abroad, his work is an interesting mix of multiple cultures, the symbolic vernacular and icons that have a nostalgic tone.

Yoskay Yamamoto.

Sorry 4 ruining ur moment, 2012, papier-mâché *daruma* with hand-carved wood.

Yamamoto

What are the underlying messages you would like to portray with your sculptures?
A lot of the work is based on popular icons and other childhood characters that I modified and re-sculpted. In the beginning, I was having fun, just taking over an iconic character and modifying it with my own style. I enjoy the oddness of these modified sculptures; there is something quite disturbing about them in a cute way. Then I started to spend a little bit more time on adding more comedic value into the titles and the sculptures. I had an old vinyl devil figure that I modified and I added a

carved spork for him to hold. And I titled the piece *Trying to Be More Practical*.

Some of the other figures have darker, satirical undertones to them. *Who's the Daddy?* is a modified Hello Kitty figure who is pregnant. It is my way of pointing out the teenage pregnancy problem, and how it is romanticized and glorified in shows like *Teen Mom* on MTV. *I'm Not Fat, I'm Just an American* is a modified Bart Simpson figure made extra chubby to draw attention to child obesity. But even in these more serious social issue pieces, I tried to deliver the message with a sense of humour.

In your opinion, what are some fundamental differences in the ways cuteness is portrayed and perceived in American and Japanese culture?
I think cuteness in American and Japanese characters works in a similar way. They are created to be adorable and cuddly to reach their target audience. I think Japanese characters tend to have bigger heads and smaller bodies than American ones.

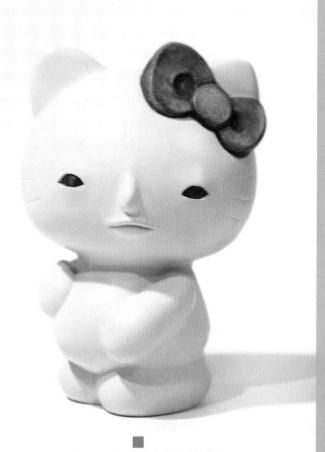

Who's the Daddy?, 2012, mixed media sculpture.

What purpose do you think cuteness serves in Japanese culture?

I think manga culture has a lot to do with the Japanese fascination with cuteness. Manga characters are often used in advertisements and commercials to promote corporations, products and services. I think people connect cuteness to a sense of comfort on some level, and a lot of companies take advantage of that.

Do companies mind you tweaking their characters?

I've never had any issues with a company so far and I hope it stays that way ...

do you remember me...?, 2012, cast resin, edition of 100.

Shojono

Shojono Tomo literally means 'little girl's friend', but is best known as the name of a magazine from the early 1900s that is considered very important in *shojo* manga culture. The artist who cheekily takes her name from this magazine creates work imbued with frenetic, punkish energy. Tomo herself has a crazy sense of humour, and is a ball of good vibes.

Tomo

Where do you get inspiration for your chaotic work?
I really love watching things like the rubbish that gets picked up by a typhoon and comes whirling over. I wonder where the items come from, and I make up stories about them.

Judging from your name, I take it you like manga?
I like manga for both boys and girls, but in particular, I love things that transform, like robots. My other favourites were *Yatterman* and *Mazinger Z*. My older brother let me read his, so I often looked at titles for adults. I would go out and buy *shojo* manga but around me there were a lot of people involved with weird subcultures, people that were slightly older – they also introduced me to Western music.

I really love Showa-era [1926–89] manga. A lot of the older titles have storylines in which people totally evolved and transformed. Even *shojo* manga titles in the past had sorrowful and melancholy narratives. Nowadays, the protagonists are usually happy, they fall in love, and then get it on. It's quite banal.

Shojono Tomo.

Can you tell us the concept behind *Porno Invaders*?

Office ladies would get a run in their tights and just throw them away, and these discarded tights would be devastated, get pissed off and take revenge. I made this idea into a movie and a game.

How do people react to your work abroad compared to here?

In Japan, only weirdos, intellectuals and gays like my work. Overseas, my company name is Porno Invaders, and people get excited just over that. They like black humour as well. At my shows old ladies will turn up wearing head-to-toe pink or purple. They don't worry about age, they just wear what they want! In Japan, people are really concerned with how others see them.

But isn't there a culture that resists this in Japan?

'Adults' and people that like self-expression are separated by a wide river.

Is it difficult to live as an artist in Japan?

Yes. First, if you make art, there is nowhere to put it! There is no system to support artists. Second, art supplies are very expensive. In Japan, if you are an artist who works without commercial viability in mind, it is difficult to exhibit. Some people have crossed that threshold, but quite often they go overseas.

You seem to be labelled as a 'kawaii artist' overseas. How does this make you feel, and why do you think Japanese people like cute things?

I think kawaii became prolific as a culture because Japanese guys like things that are weaker than them – which make them feel superior – and girls pander to this. American girls have rifles and protect their families, whereas Japanese girls start screaming 'Help me!' when they see a cockroach. They don't really fight. The samurai spirit of the Japanese man has become a cockroach killer.

Child Play 753 Kimono for 3age, 2009, antique kimono silk, vinyl, plastic, acrylic, cotton.

Koinobori for Nicki Minaj (Gift for Nicki Minaj), 2012, polyester, acrylic.

*Skin Ship
Burny Tee-Shirt
(Chocolate
Destiny)*, 2011,
cotton, acrylic,
fabric paint.

Witch Doll (Tooth),
2012, polyester,
cotton, plastic.

I think it's fine to call something 'cute' superficially, such as in cosplay. But in reality, it's all about 'Please look at me, please acknowledge me!' It's a sign of weakness in which being kawaii supersedes everything else. Whereas before, I think it was more about digging into one's interior rather than just looking at the exterior.

If the image of Japan becomes sushi, tempura and kawaii it would really bother me. In fact, I wanted to do an exhibition called 'un-kawaii'.

Where does kawaii culture come from?

I think it is the notion of 'adult children'. Salarymen read manga on the train whereas in America, once you are an adult, the attitude is, 'Pokémon is for kids only.' Americans are proud of becoming adults, whereas in Japan, if you are a child you are protected.

213

Framenka Mermaid, 2006, paper, acrylic, oil pastel.

Junko Mizuno is a manga artist and illustrator whose work is both charming and disturbingly macabre. While her paintings are executed with delicate brushstrokes in saccharine, pastel colours reminiscent of children's books, her subject–matter ranges from knife–wielding pin–up girls to deranged nurses, blood milkshakes and eyeballs with six breasts. While they are undeniably cute, her creations also fuse horror, psychedelia, eroticism and fetishism to create worlds that are whimsical and nostalgic, yet grotesque and unsettling.

Junko Mizuno

Venus Cake: Sushi,
2012, acrylic on
canvas.

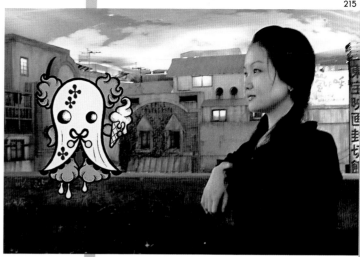

Junko Mizuno.

*Venus Cake:
Oranges*, 2012,
acrylic on canvas.

In art, are there specific traits that make something cute?
When I find characters in art cute, it's not because of their shapes or sizes. It's the innocence that appeals to me. I don't like characters that look as though they know they are cute. I usually prefer badly designed, sad, failed-to-be-cute characters that I find at dollar stores over perfect-looking ones created by clever designers who know what sells.

What aspects of kawaii do you appropriate or, conversely, reject in your art?
I enjoy drawing cute animals and creatures. What I reject is drawing kawaii girls just to attract Japanese men who want girls to be sexy and innocent/ignorant at the same time. I do love drawing sexy women, but that's just for myself, not for attracting men.

What aspects of kawaii culture did you grow up with?
I grew up with girls' comics, toys and animation on TV. All the things that were made to entertain little girls were cute, so it was impossible not to get influenced by the stylized cuteness. I thought that was normal until I started travelling abroad, but now I know it is specific to Japan.

Sanrio characters from the 1970s were definitely one of the biggest influences on my art. What I loved was not only the cuteness of the characters, but also their worlds and stories. Sanrio's products were very well designed and inspired me to create something of my own.

How do you feel when people refer to your work as kawaii?
I'm basically happy with people taking my art any way they want. I don't want to tell them how to feel about it. If they say it's kawaii as

a compliment, I just appreciate it, although I don't feel comfortable if they think I'm just part of the trend/hype, or I'm exploiting the Japanese cute style. I love cute stuff but am also cynical about the Japanese idea that everything should be cute. My art style developed naturally by absorbing what surrounded me as I grew up. So the Japanese cuteness they find in my art came naturally, as opposed to being shoehorned in.

How have you seen kawaii culture being embraced in the West?
I can tell that more people in the West have been getting into the culture recently, but it's still not as big as it is in Japan. Some fans seem like they are trying to turn Japanese and appreciate the culture in the same way that Japanese people do. Others take it as something exotic and enjoy it as a different culture.

Burger Time!, 2011,
digital image.

It's interesting that my work is often seen as typical 'Japanese kawaii art', whereas in Japan, people construe it as unusual, Westernized underground art.

I think it's funny when the word is used as a noun ['I love kawaii!'] because it's supposed to be an adjective in Japan.

Would you say that kawaii culture primarily evolved to exploit the spending power of women, who then use their cuteness to attract men?
The culture is so complicated that it's hard for me to understand, even though I was born and grew up in Japan. I've heard that babies unconsciously use their cuteness to get the attention of mothers. I think the cuteness of babies and the cuteness Japanese women use to attract men are totally different. When a woman likes something cute, such as a small animal, it's not necessarily because she wants to attract men! Maybe it's just amusing to her, or maybe it satisfies her maternal instincts.

It seems to me that the way Japanese men prefer young, cute and innocent girls has a lot to do with a Lolita complex mixed with a weird mama's boy-ness. Many of them want women to be like young-looking sex dolls and caring mothers at the same time. There are, of course, a lot of women who make themselves look young and cute just to attract men, but not all kawaii fashions are appreciated by men. For example, most Japanese men are intimidated by gothic Lolita girls.

Why do you think that look is so highly lauded in Japan?
I think it's just because it started in Japan. Also, Japanese people have a tendency to follow the majority, so it's very easy to generate hype here. If the media say something is trendy, it spreads really fast.

Mermaid's Purse,
2011, digital image.

Osamu

Watanabe

Osamu Watanabe is an artist who meticulously arranges plasticine, wax and clay fake food to make gorgeous, opulent sculptures — what he calls Fake Cream Art. Among his Fake Cream pieces are homages to Rodin's *The Thinker* and Botticelli's *The Birth of Venus*, Zen gardens, unicorns and crocodiles, all lovingly adorned with blobs of cream, tiny puddings, strawberries and jellies. Watanabe's world is the epitome of all things kawaii: pastel, sweet, adorable, romantic and feminine.

Osamu Watanabe holding one of his creations.

How did this obsession with cream come about?

My mum taught patisserie-making when I was a child, and I watched her at work. When I was in art school, wondering what form my own artistic expression should take, it occurred to me that I could make sweets into art. I also had an older sister and, because of her, I was looking at *shojo* manga and the illustrations of Macoto Takahashi and his romantic world. These are my main inspirations.

What was the first Fake Cream Art piece you completed?

I just made a bunch of regular cakes, and from there I started to move onto larger things like tables and chairs!

What is the process like?

If the work is based on a pre-existing item, I will decorate it, and if there isn't an item in the shape that I want, I get it made and then make small parts with plasticine and wax. I then pipe the modelling paste.

*Sweet Room —
Table and Chair,*
2011, modelling
paste, clay, acrylic
paint, resin.

Another Legend:
Venus Birth, 2007,
plaster, modelling
paste, plastic.

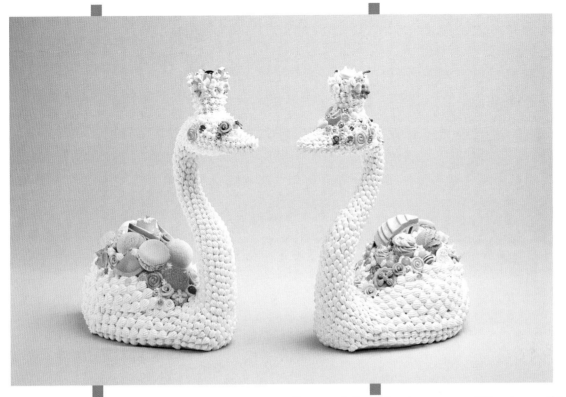

Sanctuary Swan,
2012, modelling
paste, resin, clay,
acrylic paint, iron.

Unicorn, 2012,
modelling paste,
resin, clay, acrylic
paint.

Can you tell us about your photographic works?

I go to famous places – world heritage sites like the Gobi desert in Mongolia, the Golden Pavilion in Kyoto and Big Ben – and decorate the sites with small blobs of cream and take photos. We perceive things really differently according to whether they have cream or no cream. For example, these places might seem really solemn and distant to us, and just by having the cream there, that sense of distance changes – they suddenly become really close and familiar.

How does the public react to your work differently overseas compared to back home in Japan?

Food samples are instantly recognizable in Japan, whereas overseas they don't have that culture, so firstly, they tend to be surprised that the food is fake – and, on top of that, that it is made into art. So the reaction overseas is better, as here, the public just sees the works as food samples.

Why do you think Japanese people like cute things?

In Japan, it's not easy to determine what kawaii is exactly, but if you look at its roots, it is something that expresses one's inner world and feelings – the love of something that only you understand within yourself. The externalization of that is kawaii culture. It's a real Japanese original culture. Even older girls like cute things and it is quite easy to accept. I don't really think that older people overseas are into cute things, whereas in Japan, people who grew up with kawaii things continue to love them as they grow older.

image credits

acknowledgements

A big thank you and love to everyone
who contributed to the book:

Mum, Crane, Kei Johnson, Ali Gitlow
at Prestel for editing the work, Martha
Jay for the editing, Pony for the design,
Ai at Useless for the Harajuku map and
cover illustrations, Bukkoro for the deer
illustration (page 3), Risa Hoshino for the
hair and make-up (pages 92 and 112),
Takako Yamamoto at Image Tokyo (model
on page 112), Takuya Angel, Maronta
(model on page 136), Kurebayashi,
(cover model; also on pages 133 and
136), Kimiko for the handcrafted dolls
(page 112).

Caro at Sweet Streets, Yuko Ejiri at
Parco, the maids at MaiDreamin,
Toshio Kosaka at the Kyoto International
Manga Museum, Hiroko Nakamura at
the Kyoto International Manga Museum,
Hiroko Hanamura at FMG, Tomoko
Mano at FMG, Naoki Kamo, Yuka
Kirihara at Swimmer, Yurika Honda at
6%DOKIDOKI, Naoki Higuchi at White
Promotions, Kazuhiro Manabe at Sanrio
Entertainment, Makoto at Bentenkaku
Onsen in Naruko Onsen and all the
amazing locals, Ms Takahashi at the
Kokeshi Museum in Naruko, Keita
Kohara at Osaka Canvas, Mr Kawase
at Isahaya Seikatsu Anzen Koutsu,
Ayumi Suzuki at Nihon Royal Gastro
Club, Hiroaki Okuyama at Sweets Deco
Art, Yuki Tanaka at Kewpie Japan,
Ji Youn Song at Lotte Hotels, Mr Futatsuki
at Marble Mascot, Ryusaku Matsui at
Artism, Yoshihiko Takahashi at a-step
models, Miki Shimoji at EVA Air, Taka
Kira and Tim at tokyofashion.com,
Kanehisa Watanabe at Design Festa, Yuki
Tanaka at Kewpie, Masatetsu Akimoto at
Yumicomix, Masami Seki at Fine Model
International.

m(_ _)m

Prestel, a member of Verlagsgruppe Random House GmbH

Prestel Verlag
Neumarkter Strasse 28
81673 Munich
Tel. +49 (0)89 4136-0
Fax +49 (0)89 4136-2335

www.prestel.de

Prestel Publishing Ltd.
4 Bloomsbury Place
London WC1A 2QA
Tel. +44 (0)20 7323-5004
Fax +44 (0)20 7636-8004

Prestel Publishing
900 Broadway, Suite 603
New York, NY 10003
Tel. +1 (212) 995-2720
Fax +1 (212) 995-2733

www.prestel.com

Library of Congress Control Number: 2012952513

British Library Cataloguing-in-Publication Data: a catalogue record
for this book is available from the British Library. The Deutsche
Bibliothek holds a record of this publication in the Deutsche
Nationalbibliografie; detailed bibliographical data can be found
under: http://dnb.d-nb.de

Prestel books are available worldwide. Please contact your nearest
bookseller or one of the above addresses for information concerning
your local distributor.

Editorial direction: Ali Gitlow
Copyedited by: Martha Jay
Production: Friederike Schirge
Design and layout: Pony Ltd., London

Origination: Reproline Mediateam, Munich
Printing and binding: Neografia a.s., Slovakia

Verlagsgrupe Random House FSC-DEU-0100

MIX
Paper from
responsible sources
FSC® C020353

The FSC®-certified paper Profimatt has been supplied by Igepa,
Germany.

ISBN 978-3-7913-4727-1